751.45

This book is to be returned on or before
the last date stamped below. 75! '5

SALLY BULGIN

OILS

MASTERCLASS

LEARNING FROM PROFESSIONAL ARTISTS AT WORK

DEDICATION

*To my family, friends and in memory of
Bernard Denvir.*

ACKNOWLEDGEMENTS

*I would like to thank all the artists represented in this book for their enthusiastic cooperation throughout the various stages of its production, and especially Christopher Baker for allowing me to illustrate and discuss many of his paintings to show techniques in working practice in the Materials and Techniques chapter.
Many thanks also to Jon Lloyd of Daler-Rowney;
to Cathy Gosling, Caroline Churton and Caroline Hill at HarperCollins;
to Irene Briers of The Artists' Publishing Company; to Geraldine Christy; and to all those people without whose support I could not have completed this book.*

PHOTO CREDITS

Portrait shots of Colin Hayes, Ken Howard and Ben Levene were photographed by Nigel Cheffers-Heard; and Meg Stevens by Robert O. Eames. Kyffin Williams' portrait and paintings were photographed by Nicholas Sinclair. Colin Hayes' paintings were photographed by John R. Simmons. David Prentice's paintings were photographed by Simon Derry and are reproduced courtesy of Art First, 9 Cork Street, London W1X 1PD.

SPECIAL AUTHOR'S NOTE

Manufacturers of oil colours continuously research and develop their ranges of pigments so that by the time of publication of this book some of the colours mentioned by the *Oils Masterclass* artists may have been up-rated, or even discontinued, either because of non-availability of pigments or because of concerns relating to their hazardous nature.

First published in 1996 by HarperCollins Publishers, London

© Sally Bulgin, 1996

Sally Bulgin asserts the moral right to be identified as the author of this work

A catalogue record of this book is available from the British Library

ISBN 0 00 412755 2

*Editor: Geraldine Christy
Design Manager: Caroline Hill*

Set in Optima and Weiss
Colour origination by Colourscan, Singapore
Produced by HarperCollins Hong Kong

PAGE 1: Ken Howard,
Two Blue Kimonos,
610 × 510 mm (24 × 20 in)

PREVIOUS SPREAD: Philip
Salvato, *Sunset at Schulars*
(detail), *710 × 1220 mm*
(28 × 48 in)

CONTENTS

INTRODUCTION

There are many ways of painting in oils. But there is no one right way. Our choices, if anything, are too wide and we have inherited many stylistic options from past masters. The versatility of the medium means that oils are as equally suited to rapid, spontaneous work as they are to ambitious studio paintings and it can be difficult to know which approach to take, or how best to apply a particular approach to a specific subject – should we build up paint surfaces with a painting knife, or apply the medium in thin, transparent glazes, almost like watercolour?

Learning to paint – developing a visual language to best express what we want to say about a subject that excites us – is not about discovering a formula, however, of learning solely about materials, technical skills and the mechanics of putting on paint. These things are important, of course, but there is much more to it than that. Painting is a creative process and is as much about attitude and training the eye to look, analyse and invent, as it is about manual dexterity. This is not so easily taught, but it can be developed, especially by studying and understanding other artists' working processes.

This is the intention behind *Oils Masterclass*, in which eight professional artists, whose subject matter and approaches reveal the many choices available to us in oil painting, discuss their ideas and working methods. By providing an insight into their thoughts and painting experiences, and by sharing their hard-earned knowledge, they offer us the opportunity to take what is most useful to us

and to incorporate this into the development of our own work. From among them we should be able to find something that accords with our own temperament and personal vision – and even from those with whose work we are least comfortable, there are important lessons to be learned. Ultimately, in explaining and showing the development of their work from the choice of subject matter to the final painting, we can be inspired by their example.

As you will see, one of the greatest advantages of the medium of oils to the *Oils Masterclass* artists is its flexibility. When colour is applied to the painting surface it can be altered, pushed around or removed completely; tones and colours can be modified, heightened or subdued. Many of the ways in which oil colours can be applied are demonstrated by specific examples in the Materials and Techniques chapter, with accompanying explanatory captions. These have been selected to show techniques in working practice. By extending your knowledge about what the possibilities are, you will broaden what you yourself can do in your own painting. Amongst other methods you will see how the paint can be scumbled and glazed, blended, stippled and dabbled, scraped back, applied with a knife, drybrushed, or worked over coloured grounds, and how different mediums can be added to change the working characteristics of the paint.

All these elements are exploited in a variety of ways and to different degrees by the artists in *Oils Masterclass*. I have learned a great deal by spending time with them, watching them work and asking questions about why and how they paint as they do. They have been generous in explaining their approaches and working methods and the information and stimulus they have provided will stimulate both newcomers to oils and more practised artists alike. I hope you will enjoy learning from them as much as I have done, and that you will find similar inspiration in their work.

Sally Bulgin

MATERIALS AND TECHNIQUES

The ease of manipulation of oil colours is regarded by the *Oils Masterclass* artists as one of the medium's most important assets. The fact that such a wide range of effects – from transparent glazes to opaque layers of impasto – can be achieved in the same painting, and that colours do not change to a great extent on drying, adds to the appeal of the medium. Any potential disadvantages, such as long drying times, are turned to advantage by the artists represented here, and their careful selection and use of materials, and knowledgeable handling of technique, means that the possible darkening or yellowing of colours over time, or the cracking and flaking off of paint layers, are combatted. Used with an informed understanding about the special properties of this paint, oil colours offer the painter a versatile, sensuous, durable and permanent painting medium, as the great masters have shown over the centuries.

▶ Blocking in colour
One of the keys to the success of David Martin's dramatic still-life compositions, characterized by their striking colour and imaginative design, is his method of 'blocking in' colours. This approach allows him to see how areas of colour work with each other as he develops the painting. As in The Decorated Jug *(oil on canvas, 875 × 875 mm, 35 × 35 in) his interest is in the distribution of colours rather than the careful description of detail; the shapes of the flowers and leaves here are generalized into a series of coloured shapes against the vibrant background areas. To achieve this he uses paint thinned with turpentine, blocking in the initial areas of colour with a rag, before introducing thicker areas of bright colour with a brush in the later stages.*

OIL-BINDING MEDIUMS

To widen your technical range, it is important to understand the make-up of the paint and how this affects its behaviour. The inherent characteristics of oil paints depend, for example, on the nature of the oil-binding medium or agent which fixes the colour – the pigment – in the dry paint film.

The oil-binding medium most commonly used in artists' quality ranges of oil colours is linseed (extracted from the flax seed). Safflower and sunflower oil, which dry more slowly than linseed oil, are used when the yellowing of linseed oil will affect the final colour – especially the whites. These oils dry on contact with the air and are soluble when wet in solvents such as distilled turpentine, but become insoluble on drying (it can take from six months to a year for an oil painting to become completely

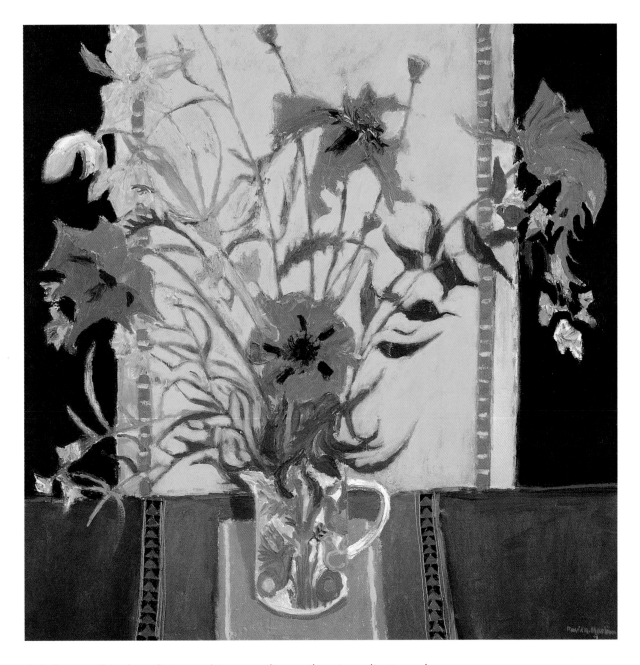

dry). Poppy oil is slow drying and is used for whites and pale colours and to modify the consistency and drying time of linseed oil colours, although it is not widely used as the sole binding vehicle in artists' colours. Walnut oil has similar characteristics to poppy oil. However, both take second place to linseed oil as a popular binding medium among the artists here.

Because every pigment absorbs different amounts of oil-binding medium other ingredients such as driers or extenders are added by most manufacturers to ensure that colours perform consistently within established limits.

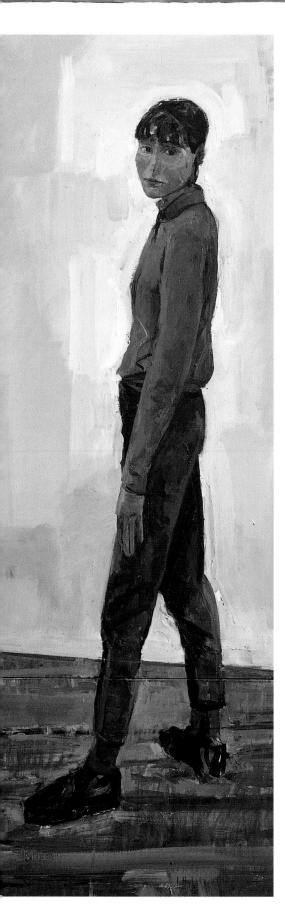

Scraping back and tonking (to make corrections)

An advantage with oil painting is that corrections can be made by scraping off wet paint with a palette knife. In Christopher Baker's Sam (oil on linen, 1830 × 635 mm, 72 × 25 in) the head became overworked (see detail), so he scraped off this area with a palette knife (at the end of a painting session), leaving a ghost of the original image. This acted as a guide when he came to redefine the head the next day.

Scraping back is a useful technique in its own right and allows you to develop a painting in a series of thin layers of colour without leaving brush marks. Because the knife removes paint from the raised canvas, leaving paint in the weave, this technique unifies a surface and helps to create atmospheric effects.

Some artists scrape down an entire canvas at the end of a painting session, preferring to begin again the next day rather than overworking a painting. An alternative, more gentle method for removing paint from an overloaded surface is that of 'tonking', in which a sheet of absorbent paper (kitchen roll or newspaper) is placed over the area, rubbed lightly with the palm of the hand, and lifted off carefully. The paper absorbs the oily, top layer of paint, leaving a drier, thinner stage in which brush marks and details are smoothed away. This acts as a useful underpainting on which to continue to develop the composition.

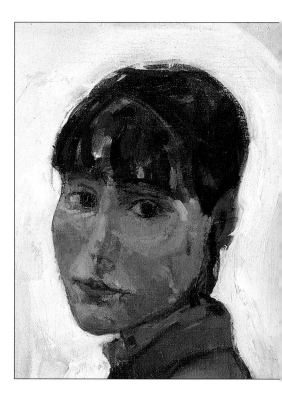

It is still good practice, however – and especially with home-ground colours – not to use fast-drying, high oil-absorption (high oil-content) colours (such as cobalt blues) for an underpainting – unless these are applied very thinly or in tints with white, for example – as further layers of low oil-absorption (low oil-content) colours may crack. This is because the lower paint layers will take longer to dry and will shrink a little more than the top layers, causing the hardened, leaner paint layers on the surface to crack and even flake off (see 'Fat over Lean', page 17). In effect, more oil equals a more flexible paint.

Oil absorption is difficult to gauge accurately for manufactured colours, however, as this is affected by the extenders – pigments which are transparent in oils and have an oil-absorption rate of their own – that are added to improve or modify the behaviour of paints, and the exact recipe for each manufactured tube colour is not readily available.

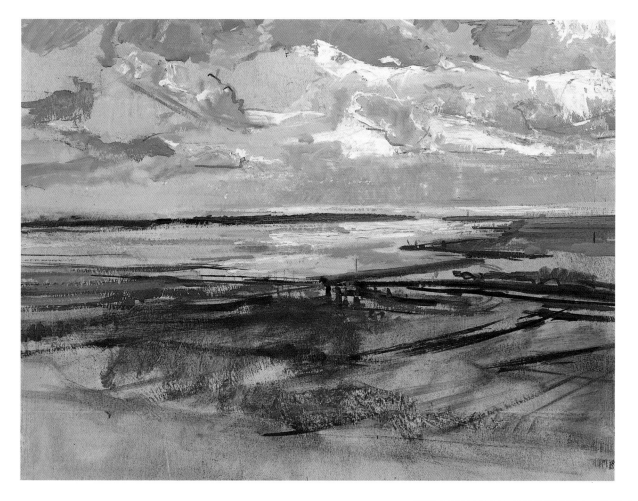

Although there is no need to impose unnecessarily strict restrictions on your oil-painting technique by worrying too much about these issues, especially as these are largely taken care of by the stringent standards which govern the manufacture of today's oil paints, a general awareness of these characteristics will nevertheless lead to more informed painting, an even better paint structure, and a greater understanding of the oil paint medium. For those with a serious interest in the subject, more detailed information on all aspects of oil painting, including a guide to the degree of oil absorption of various pigments, is available in Ralph Mayer's indispensable *The Artist's Handbook of Materials and Techniques* (Faber and Faber).

Applying impasto with a knife

The application of thick impasto with a painting knife (note the cranked shaft which distinguishes it from a palette knife) suits confident artists who enjoy working with sensuous, creamy paint. In the detail (right) of Langstone Harbour, Portsmouth *(oil on board, 480 × 635 mm, 19 × 25 in) Christopher Baker exploits the technique to create streaky sky and water effects and ridges of impasto that catch the light and add to the liveliness of the paint surface.*

It is also a useful technique for adding final highlights. In addition, the crisp straight lines required in architectural

subjects can be achieved with the edge of the knife (see detail), while glazing with a painting knife is possible by applying a transparent colour over an underlying one.

11

DRYING TIMES

Ralph Mayer's handbook also gives detailed information about the drying times of various pigments, some of which – Raw Umber, for example – speed up the drying process of the oil in which they are bound, while others – such as Zinc White – have no such effect. As with oil-absorption rates, such differences are accommodated by the addition by most manufacturers of drying agents to ensure that all the oil colours in their ranges are touch dry within a certain time limit. Other, less well-known manufacturers, do not add drying agents, leaving it up to artists to control their own materials by selecting when to apply colours appropriately and when to introduce drying mediums.

If you select colours from a range that does not incorporate drying agents, it is important to understand the drying effect of pigments to ensure that you follow sound oil-painting practices, including allowing paint layers to dry out sufficiently before working on top (unless, of course, you are working *alla prima*). In this case it is helpful to start with fast-drying colours such as the umbers, Prussian Blue, Flake or Cremnitz White, and to avoid the slowest-drying pigments – such as Cadmium Red, Ivory Black and Zinc White – in the early paint layers (see 'Fat over Lean', page 17).

ARTISTS' AND STUDENT RANGES

Most oil-paint manufacturers offer at least two grades of paint: artists' quality oil colours and the more economical ranges that are recommended for student use and often sold under a brand name. A variety of tube sizes is available. Some manufacturers also supply large tubes of white and 250 ml or 500 ml tins in a limited range of colours for large-scale work or for professional artists who use large quantities of paint.

Artists' quality paints are divided into series which range in price from the cheaper earth colours to much more expensive colours according to the cost of the pigments used. Student quality colours are usually priced all the same and are cheaper than artists' quality ranges because they include less expensive, alternative pigments.

ALKYD COLOURS

Also available are colours that are bound in a fast-drying, oil-modified alkyd resin. These are compatible with, and behave in a similar way to, artists' and student ranges of oils, with the advantage that they dry more quickly, making them ideal for underpainting; for completing a painting in one session; for making quick sketches; and for adding to, and speeding up, the drying time of oils. The drying time of alkyd colours is consistent across the range, and they dry to a durable paint film that resists cracking. Alkyd colours are economical because the range includes the less expensive synthetic organic colours. The principle of working fat over lean applies equally to these colours.

DURABILITY AND HANDLING QUALITIES

The permanence and lightfastness of colours vary. Some may lose or change their colour on contact with sunlight, or with other pigments, or

▶ **Scumbling and broken colour**
Scumbling an uneven, broken layer of opaque, semi-opaque or transparent paint over another dry layer allows you to modify the colour underneath, as in Ken Howard's Lizzy, St. Clements Hall, Mousehole (oil on canvas, 1220 × 610 mm, 48 × 24 in). This can help create a textural painting surface that conveys the subject – in this case the sparkling and illuminating effects of light – more effectively than flat colour. Here, Ken has scumbled mostly thin veils of colour over underlying colours in an expressive manner, using a brush, but scumbles can also be applied with fingers, a rag, a sponge, or a palette knife. Different thicknesses of paint can also be incorporated. Note in this painting the thicker patches of pale ochre suggesting shafts of light falling across the floorboards in the foreground.

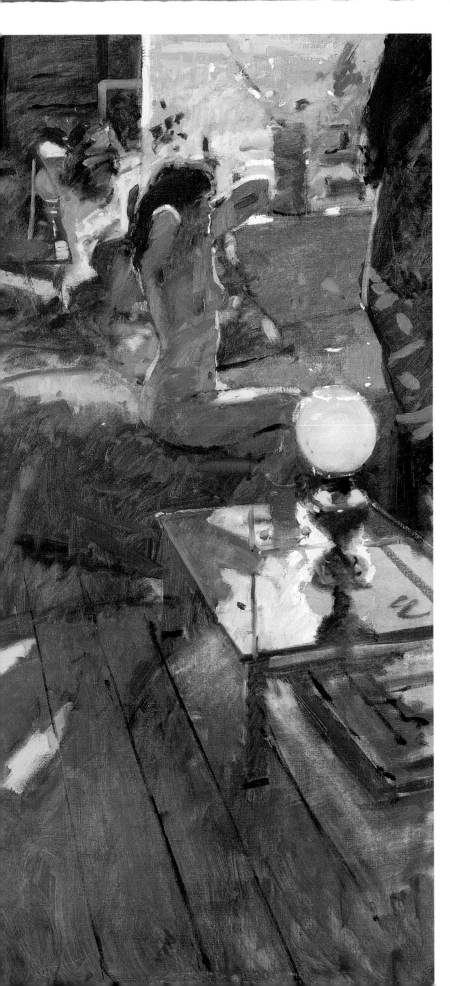

as a result of pollution. Permanence ratings are given by manufacturers, so check their information to be sure about the durability of your colours before buying. Meg Stevens, for example, selects only artists' quality colours with the highest permanence ratings.

Colours in some ranges have been tested specifically for lightfastness by the internationally recognized American Society for Testing and Materials (ASTM). The ASTM grades colours on a rating from I to III according to their resistance to fading: I is the highest lightfastness rating, although both I and II are considered permanent for artists' use. This information is also available in manufacturers' literature.

The texture and consistency of oil colours also vary. Raw Umber and Yellow Ochre, for example, are 'stiffer' in consistency than the more 'buttery' and oilier cadmium colours. To get to know the handling quality of a colour that is new to you, squeeze out a small amount and work it with a brush.

While most of the artists in *Oils Masterclass* prefer to use artists' quality colours and pay attention to permanence ratings and lightfastness, many of them select colours from different brands to build up their own personal palettes. David Prentice, in particular, likes to have available as many colours as possible, and buys oil paints made by a variety of well-known and less well-known manufacturers. If you follow this example bear in mind that the preparations for colours differ from brand to brand, making each one slightly different in handling quality or consistency. Some brands, for example, are manufactured by milling the pigment into a gel, derived from a mixture of aluminium stearate and linseed oil,

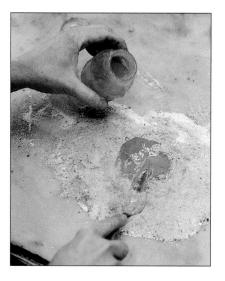

Making your own paints
Philip Salvato makes his own
paints. Here you can see a
studio assistant beginning to
mix powder pigments with a
binding medium of stand oil
and alkyd resin to make a
quick-drying paint for oil
sketching outside.

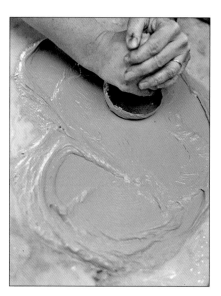

The paint is ground into a
creamy consistency using a
muller before being put into an
empty tube, bought from
Philip's local art store. The
tube is then crimped and
labelled for storing.

producing a paint which is easy to brush out. Other brands are made by combining pigment with the minimum of additives and the correct oil-binding medium to form a paint closer to the type originally used by the old masters. This paint is stiffer in consistency and therefore more suitable than oilier brands for painting with thick, palette-knife applications of colour, as Kyffin Williams does.

MAKING YOUR OWN PAINTS

Some artists, like Philip Salvato, prefer to make their own oil colours, either for reasons of economy, or because they enjoy having full control over, and understanding of, their paints. It is not complicated to do and dry pigments are easily obtainable from specialist art suppliers. These are 'wetted' into a basic paste with white spirit, which evaporates quickly once the wetting is complete; then the oil-binding medium – usually linseed oil – is introduced and a tacky paste made by grinding the mixture on a marble slab using a glass muller. The addition of a small amount of beeswax helps to unify the paint and prevent any possible separation of the oil and pigment. Empty paint tubes are also available in which to store home-ground paints.

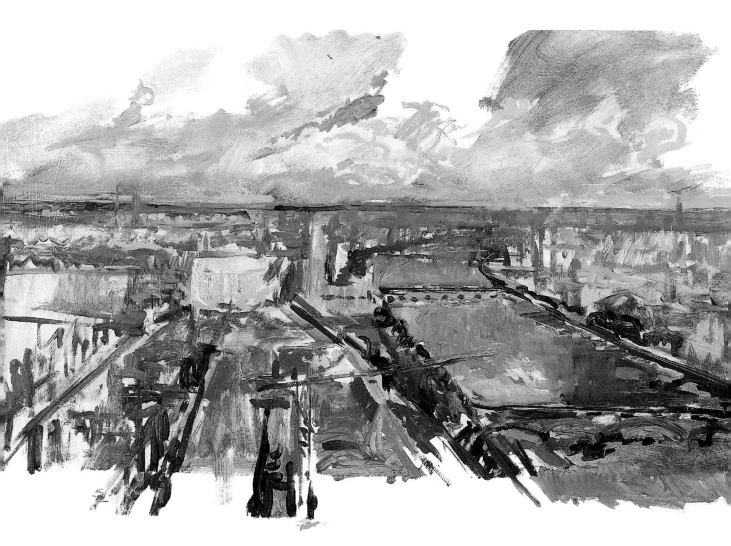

Glazing

By thinning oil paint with a glazing medium and applying it like watercolour over a white ground, as in Christopher Baker's oil sketch **From the Millbank Tower, Overlooking Westminster** *(oil on paper, 760 × 1120 mm, 30 × 44 in), wonderful luminous effects can be built up, especially when successive transparent layers of rich colour are applied over dry underlayers. This technique is equally effective over impasto paint. Here, Christopher added sprinkled ground pumice onto his acrylic gesso priming layer to give his glazed colours some texture.*

It is important not to use linseed oil to thin the paint for glazing techniques because a high proportion of oil would be needed to make the paint transparent, making it too liquid and unmanageable.

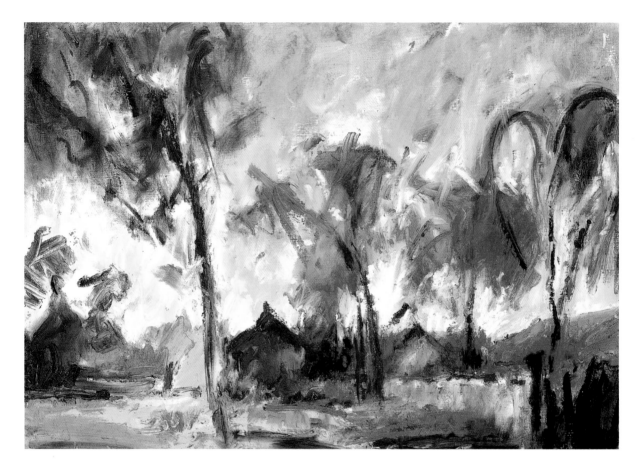

Drawing and painting with oilbars

Oilbars offer a convenient way of working with oil colours and can be used freely and expressively for on-the-spot paintings such as Jeremy Leigh's Landscape Study *(oilbar on oil-painting paper, 560 × 790 mm, 22 × 30 in).*

Because they act like a drawing medium oilbars allow you to cover large areas of a composition quickly. They can be used like crayons to draw lines, or dragged across the surface lengthwise to create wider marks of colour. The addition of a little turpentine helps to blend colours and layered scumbles can be built up by dragging one colour over another to create beautiful broken textures.

OILBARS

Oilbars are now available from some manufacturers. These can be used for drawing and painting on all traditional oil-painting surfaces. Oilbars are essentially oil paint and wax formed into different thicknesses of 'crayon' and are miscible in all mediums and solvents. They differ from oil pastels, made with non-drying oils, because they are made with drying oils such as linseed oil.

CHOOSING YOUR COLOURS

The names given to colours by different manufacturers often give little clue about the pigments they contain, or about the quality of the paint or its behaviour. To add to this confusion some colours are given different names by different manufacturers, making it difficult to compare colours across brands. Manufacturers' colour charts will help by providing information on the range and tone of the manufacturer's selection, the pigments used and the composition of the colours, and details about their use and permanence. Charts made with printers' inks to show the range of colours will not always reveal their true qualities. More accurate hand-made tint charts are available.

Making up your own colour chart for reference is a helpful way to decide the most useful colours for your own painting. Remember, though, that the appearance of the colours, and texture of the paint, will be affected by the support on which you paint, the type of ground you use and any additional mediums you decide to add.

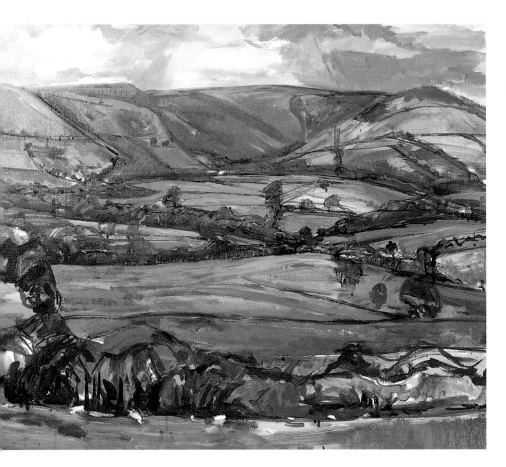

Working fat over lean

All paintings of more than one layer of paint must be built up following the 'fat over lean' rule to prevent cracking. For the initial underpainting colours must be thinned with turpentine or white spirit; subsequent layers can be 'fattened' by the addition of an oil-painting medium.

The detail (below) of Christopher Baker's Mid-Wales (oil on primed linen canvas, 760 × 900 mm, 30 × 36 in) shows how he did some preliminary underpainting in thin, lean paint – predominantly Light Red and French Ultramarine – as a basis for the subsequent layers of oilier paint. The highlight on the tree is fat, white paint straight from the tube, mixed with a touch of Lemon Yellow and French Ultramarine. Note that the complete painting consists of a variety of different paint thicknesses, which adds to its successful suggestion of the different forms and textures in this landscape.

FAT OVER LEAN

Whichever paints you use, one principle to which it is crucial to adhere if you want to ensure that your painting will not crack, is the 'fat over lean' rule. This is a fundamental technique of oil painting in which superimposed layers of paint, which should be applied on top of fresh, wet paint, or after each previous layer is dry, should be as, or more flexible than, the layer underneath. To achieve this you must ensure that you paint high oil-content colours (fat paint) over the top of lower oil-content colours (lean paint). Paint can be made more 'lean' by thinning it with turpentine or isoparafin solvents such as low-odour thinners, and the oil content of subsequent layers can be increased by adding an oil-painting medium to the colour.

DILUENTS, MEDIUMS AND VARNISHES

The consistency and drying times of oil paint can be altered by the addition of a diluent or one of the many oil-painting mediums available. The wide range of these can be confusing and it is important to understand if, why, how and what you should add to your paint to change its handling qualities, or to affect the final surface appearance.

Many artists, like Meg Stevens, choose to use only small amounts of distilled turpentine to thin their colours in the early stages of a painting. Others, like David Prentice, enjoy experimenting with a range of mediums to vary the texture of their work.

DILUENTS

By adopting the practice of adding greater quantities of distilled turpentine to thin the first layers of colour, less in succeeding layers, and pure paint for the final layers, it is easy to observe the fat over lean rule. For glazing techniques, the addition of a little linseed oil will give a more glossy effect to the paint, counterbalancing the dulling effect that turpentine can have on colours. Its addition also makes the paint film more durable, although remember that it will also retard the drying time of paint layers.

White spirit is a cheaper substitute for turpentine. Although a slightly weaker solvent, it stores well without deteriorating, but it can give the dry paint film a milky white appearance. Isoparafin solvents such as low-odour thinners are better and sold under different brand names for painters who are allergic to turpentine, or who find the smell objectionable. Oil of spike lavender provides an alternative, although it is slower drying than turpentine or white spirit.

Adding mediums to oil paints

The consistency, texture and surface finish of oil paints can be varied by the addition of one or more of the wide range of mediums available. David Prentice uses an alkyd resin to accelerate the drying time of his colours; this also makes them more transparent and slightly glossy. The jewel-like quality of colours in paintings such as So Heavy Hangs the Sky *(oil on canvas, 1650 × 1475 mm, 65 × 58 in) is partly attributable to this addition; thicker areas of colour such as those in the foreground are created by mixing wax with the medium on a glass palette.*

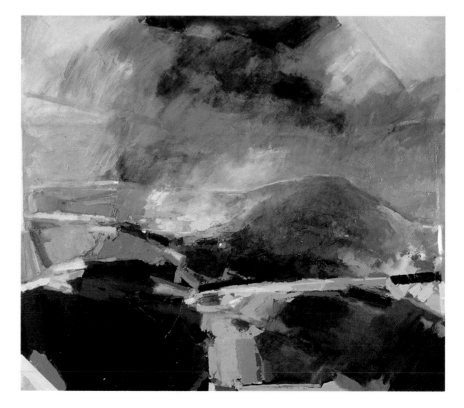

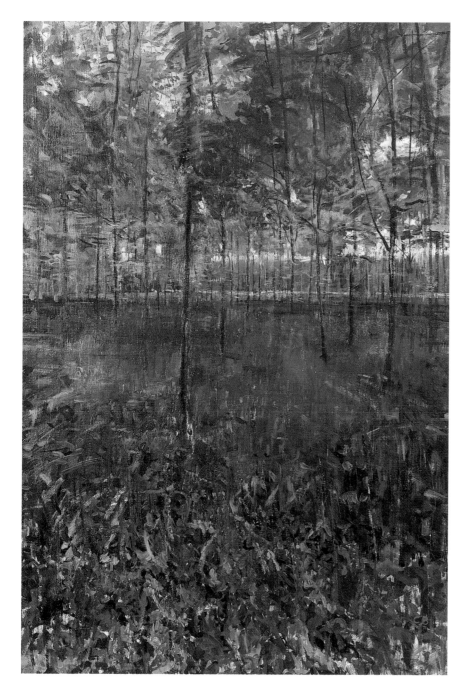

Drybrush
Lightly brushing the minimum of relatively dry paint over a textured area so that the dry colour underneath shows through is known as the drybrush technique. In Christopher Baker's Uprights in Blue (oil on linen-covered board, 1320 × 915 mm, 52 × 36 in) the more prominent foliage and suggestion of bluebells in the foreground have been drybrushed in thick paint, as you can see more clearly in the detail. Note, too, how the artist has scumbled and glazed areas to close down the tones so that the colour values are nearer to each other. This helps to unify the composition. The Burnt Umber imparimatura or underpainting is also allowed to show through in places.

MEDIUMS

Specialist art shops will be able to advise you about the different oil-painting mediums that are available, but always check manufacturers' information to be sure about what you are buying and the function for which the product is intended. The most important point to remember when using mediums to develop a painting which includes several layers of paint is always to observe the fat over lean rule.

Mediums fall into two groups: those based on fast-drying oil-modified alkyds, and those based on oils. Broadly, these can be divided between mediums that are useful for glazing techniques and thin applications of colour, and those

Coloured grounds

Working on a mid-tone tinted ground rather than a white ground makes it easier to work up to the lights and down to the darks; it provides a key against which to judge other tones and it holds the painting together from the beginning. Subdued colours such as browns, ochres, blue-greys or reds are most often used, thinned with plenty of turpentine. Acrylic paint, diluted with water, is also useful for making a tinted ground because it dries so quickly. The Burnt Umber tinted ground used to great effect in Christopher Baker's Thames Above the Tate *(oil on acrylic gesso-primed board with sprinkled ground pumice, 760 × 1120 mm, 30 × 44 in) acts as a harmonizing mid-tone throughout the study, in which it shows through extensively. It also adds a contrasting warmth to the cool blues and greys, which might otherwise have become too predominant.*

that are more suitable for impasto or thick applications of paint. Oil-based mediums can be used for glazing *or* impasto techniques, however, depending on their particular formulation.

Traditional oil-painting mediums

These are based on natural resins such as dammar and mastic and are available from manufacturers under many different brand names. Each has a slightly different formulation. The best way to decide the type of medium most suitable for your own painting is to decide first what function you wish it to perform, and then to check this against the information that is supplied by the manufacturer.

In general terms the different functions of oil-painting mediums include: the speeding up (drying linseed oil, thickened linseed oil) or

slowing down (stand linseed oil) of the drying time of colours; improved flow; controlled flow; the increase of the glossiness of colours; the increase of the transparency of colours; making colours more matt; reducing the consistency of the paint; increasing the flexibility of the paint film (thickened linseed oil and linseed stand oil mediums); increased resistance to yellowing (drying poppy oil) and resistance to the wrinkling of the paint film during drying (Venice turpentine and beeswax paste).

Oil-modified alkyd mediums

The above advice also applies to alkyd-based resins, which are also sold by manufacturers under a variety of brand names. Generally, though, as mentioned, these are especially useful to painters who like to work with thick applications of paint, or who want to speed up the drying time of colours. Usually they have a slight reddish/yellow tint and are available in either gloss or matt finish. Some manufacturers offer these in large tins to accommodate artists who prefer to work on a large scale.

Remember, too, that oil-painting mediums are intended for use *with* oil colours and should not be applied without colour as a varnish. Mediums are made from binders and are insoluble once dry.

VARNISHES

Varnishes, on the other hand, are designed to protect the final paint surface and come in gloss or matt finishes. Some of these, such as dammar varnish, are temporary and resoluble so that they can be removed if necessary for recleaning or repainting, although they become increasingly difficult to remove with age. This means that a

Blending colour

As oil paint remains workable for hours, sometimes days, colours can be blended on the painting surface with a soft brush, or the fingers, to create softly graded tones. This can be useful for skies, for example, as in Christopher Baker's View from the Trundle over Chichester *(oil on canvas board, 305 × 455 mm, 12 × 18 in) in which he blended his colours on the painting surface while the paint was still wet to create the subtle gradations of the blues of the sky as well as the greens of the fields. He used mongoose hair brushes for this painting, as they are softer than hog hair ones.*

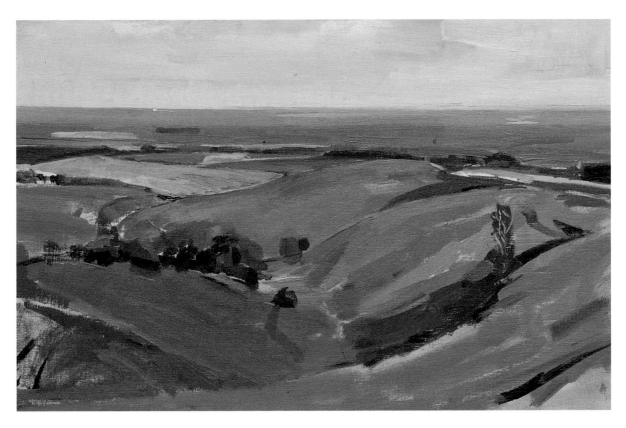

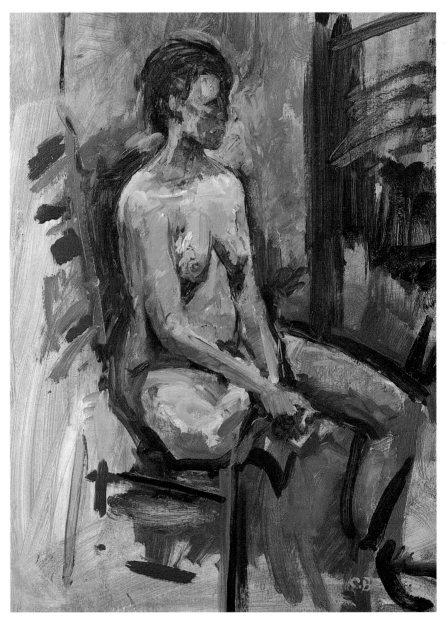

Drawing with oil paint
*Christopher Baker's nude
study* Julie *(oil on acrylic
gesso-primed mounting board,
610 × 510 mm, 24 × 20 in)
shows how oil paint can be
used as an expressive drawing
medium. The artist worked on
a Raw Umber acrylic ground,
using oil paint mixed with an
alkyd medium and retouching
varnish to speed up its drying
time. His rapid, almost
calligraphic brushwork
conveys his enjoyment of
painting directly from his
subject in this way (see detail).
The study was completed in
one painting session.*

temporary varnish used as a medium will render the paint film resoluble. Inexperienced painters would be well advised to avoid this practice since it complicates the handling of technique.

Permanent varnishes are extremely difficult to remove, but give even better protection from pollution and solvents in the atmosphere. These should *never* be used as a medium.

Some *Oils Masterclass* artists, like Meg Stevens, use a varnish to recover the gloss of colours which can sometimes be lost by the addition of too much turpentine. If you do decide to varnish, you must first make sure that your oil painting has dried thoroughly; this may take from six to twelve months – impasto and heavily textured work can take even longer. Again, check the manufacturer's information to make sure that you buy the appropriate varnish, and always follow their instructions. Varnishes are available in bottles, or in CFC-free aerosol sprays.

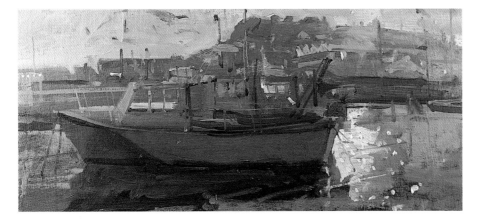

▲ Working alla prima
*Artists like Richard Pikesley,
who enjoys snatching moments
in the early morning or late
afternoon to capture delicate
light effects, often complete
their paintings* alla prima –
*in one painting session. This
necessarily means working
wet-into-wet and encourages a
lively, direct approach.
Paintings such as Richard's*
Fishing Boats and
Headland, Evening *(oil on
board, 150 × 355 mm,
6 × 14 in) often display a
greater immediacy and sense of
vigour than studio paintings.
It is important when painting*
alla prima *to leave the
lightest passages to the end so
that they remain fresh and
undisturbed. Here, Richard
kept everything low-key until
almost the last moment to
allow him to make the final
dabs of light on the water
really sparkle.*

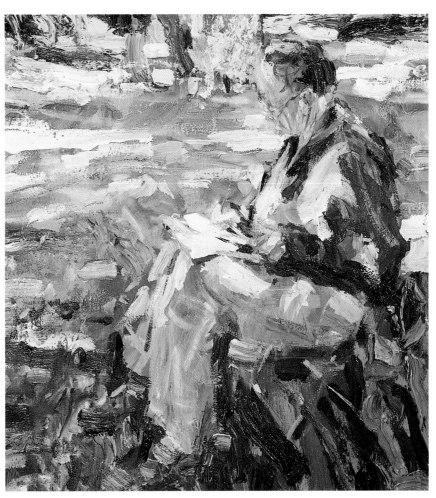

▲ Wet on dry
*The final broad stabs of colour
that dance across the entire
surface of Arthur Maderson's*
Afternoon Class,
Derriheen *(oil on gesso-
primed canvas panel,
305 × 305 mm, 12 × 12 in)*

*help to integrate the figure with
its landscape setting and were
applied wet on dry. In places
such as the figure's left arm
you can see clearly how thick,
relatively dry paint brushed
across the painting surface has
picked up the canvas texture.*

23

Oil over gouache, acrylic
and pastel
*An underpainting in gouache
or fast-drying acrylics makes
an excellent and convenient
base for an oil painting. You
can also paint in oils over
pastel, which can create
interesting textural effects.
Arthur Maderson combined all
four media in* A Fair Deal
*(mixed media on canvas
mounted on marine-ply panel,
610 × 735 mm, 24 × 29 in),
in which he applied his
underpainting first in thin
gestural washes of gouache
and acrylic paint, followed by
broad slashes of pastel through
which the underpainting was
allowed to show through, and
finally thick stabs of oil paint.
The variety of textures
produced by this use of
different media can be highly
expressive, as this work shows.*

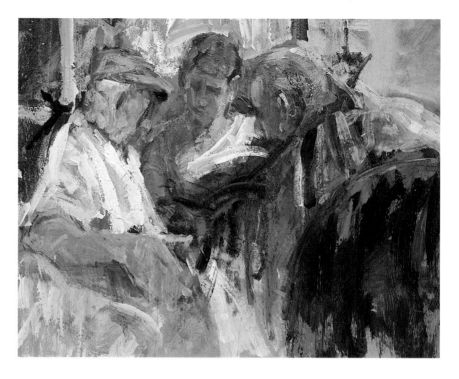

OIL-PAINTING SUPPORTS

Oil paints can be used on almost any surface as long as it has been properly prepared. Smooth surfaces must be sandpapered to provide some tooth to which oil paint will adhere – otherwise it will tend to slip and slide – while canvas must be sealed (primed) before the paint is applied, to protect the fibre from the oil in the paint. (See 'Sizing and Priming', page 28.)

Canvas
Canvas is available in various weights or thicknesses, and weave, and comes ready-stretched and ready-primed, which is a convenient although expensive way to buy it. Alternatively it can be purchased cut to a required size from the roll from specialist art shops, in which case you will need to stretch and prepare it yourself – although some art shops do offer a bespoke canvas-stretching service.

Hessian or jute canvases provide a heavy weave which give a grainy effect to the final painting, while linen is the preferred canvas of many professional artists; this too comes in a variety of weights and textures. Finest linen with a close weave and smooth surface provides the ideal surface for portrait or detailed work.

The range of weaves available in linen canvas for artists' use is greater than that available in cotton duck, which is also widely used as a surface for oil painting. Compared to the beige colour of raw linen, cotton duck has a soft white tone. The best weights for artists' use are between 12 oz (410 gsm) and 15 oz (510 gsm); below 9 oz is too flimsy to provide a stable support for oil painting. Polyester, rayon and other synthetic fabrics are also available, although these are less popular.

Rigid supports
Ready-primed canvas boards are more economical and easier to transport than stretched canvases. Ken Howard makes his own by affixing fine muslin to hardboard

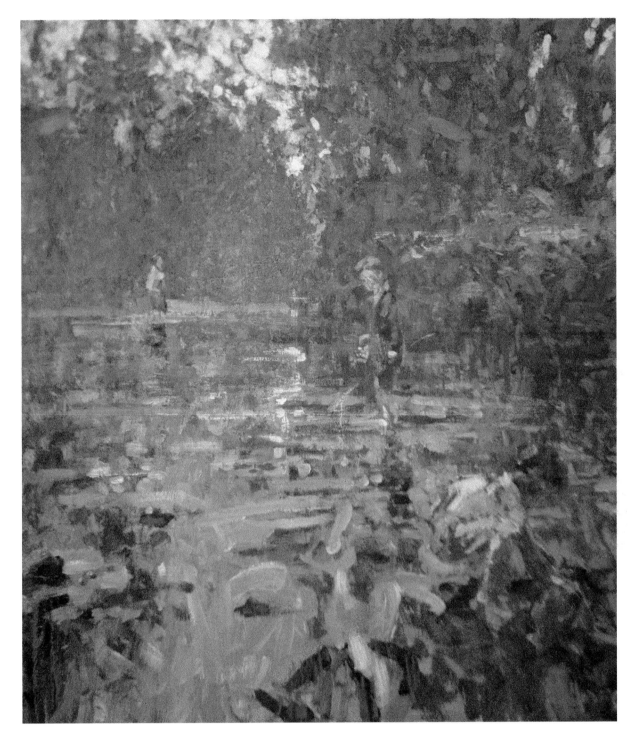

with rabbit-skin glue. The surfaces of canvas boards are, of course, more rigid than those of stretched canvases and have less 'give', but this can be an advantage for artists who paint vigorously or who do a lot of scraping back during the development of a painting.

Stippling dabs and dots of colour
Most of Arthur Maderson's **Towards Fresh Woods** *(oil on gesso-primed canvas panel, 1120 × 1015 mm, 44 × 40 in) consists of dabs and dots of juxtaposed colours which allow the previously applied colours to show through. This technique and the use of fairly pure colours recalls the Impressionists' use of broken colour.*

25

Working on plywood supports

Christopher Baker often uses 12 mm (½ in) thick laminated plywood as the basis for small oils such as By Arrangement (in progress, 470 × 405 mm, 18½ × 16 in). He pastes pieces of fine Egyptian cotton to the plywood by first coating the board with rabbit-skin glue, stretching the material on top of this and applying another coat of rabbit-skin glue while this is still wet, followed when dry by a further thin layer of rabbit-skin glue. A final thin coat of oil primer when this is dry creates a robust and easy-to-frame surface on which you can use oil paint in watercolour-like washes to exploit the luminosity of the ground in the painting.

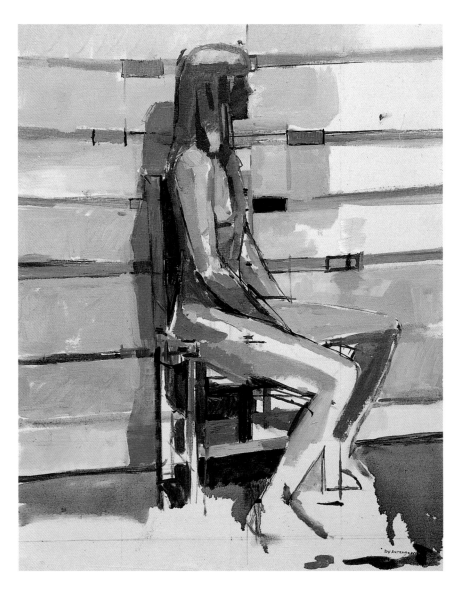

With the correct sizing and priming, wooden panels cut from mahogany make ideal supports for oil painting. Plywood is also suitable and comes in various thicknesses. It is more easily available than mahogany; size and prime it on both sides to prevent warping. Hardboard is a cheap alternative, favoured especially by students, and can be painted on either its rough or smooth side, depending on the texture you prefer. Again, prime it on both sides to help prevent warping. You will need to batten the reverse side to strengthen for hanging purposes.

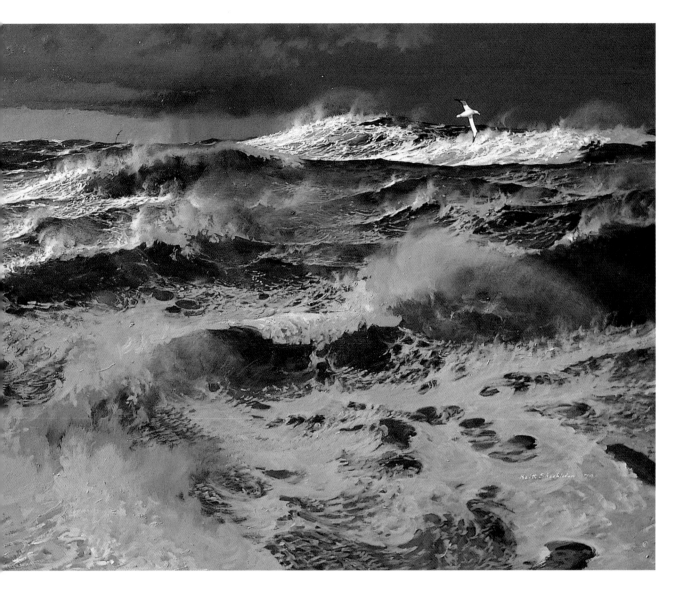

Rigid supports

Itinerant wildlife artist Keith Shackleton always paints on the rough side of hardboard, partly because it can be cut to whatever shape or size required and cropped later to change or improve a composition, and partly because of its durability, which is important for him as he is an extensive traveller. Paintings such as Evening: Drake Passage *(oil on hardboard, 610 × 915 mm, 24 × 36 in) are painted on the rough side of hardboard coated with*

Polyfilla (cellulose filler) applied with a squeegee to smooth out the initial texture. This is then sanded and primed before he starts the painting. Another advantage of this rigid support for Keith is that if a painting is not working he can rub it down when dry with a power sanding machine.

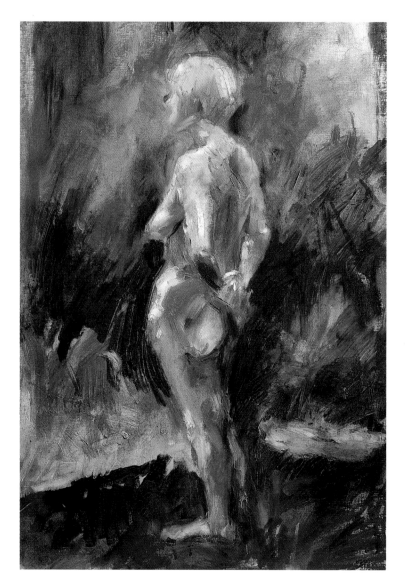

Sketching on oil-painting paper
Oil-painting paper is ideal for quick oil sketches such as Jeremy Leigh's Life Study *(oil and oilbar on oil-painting paper, 735 × 610 mm, 29 × 24 in). He thinned his paints with an alkyd medium to speed up their drying time, and established the tones by roughing in the composition with washy paint, then wiped away the lighter tones with a rag soaked in turpentine. He then drew into the composition with oilbars.*

Oil-painting paper
Sheets of specially prepared oil-painting paper with a simulated canvas surface, pinned or taped to a drawing board, make an economical surface on which to work out ideas for more finished oil paintings, or for outdoor oil sketching. This paper can also be bought in card-backed blocks.

SIZING AND PRIMING

As already mentioned, surfaces must be 'sealed', or sized, to protect them from damage by the harmful acids in the subsequent oil primer, paint and solvents used in oil painting. Sizing also prepares canvas for painting by making it taut and by reducing its porosity. Rabbit-skin glue is a traditional size and can be bought in granules or sheets; it is simple to make by following instructions. Alternatively you can buy ready-prepared size, or acrylic and other synthetic sizes.

All the *Oils Masterclass* artists emphasize the importance of a properly sized canvas and well-prepared ground as this initial preparation has a direct effect on the quality of the tones and colours in your painting and its resistance to ageing. Generally, it is more economical to do this yourself, but as noted earlier, you may find it more convenient to buy ready-stretched, ready-primed canvas.

The purpose of a priming layer is to provide a durable, stable ground to which subsequent paint layers will adhere firmly. Applied to canvas, the primer also helps to integrate the canvas weave to create a tougher painting surface. Lead white primer is available as a thick paste in cans and is the most suitable primer for oil painting on rabbit-skin glue-sized canvas as it is the most flexible white pigment and dries to form a tough paint film. It is also low in oil content, and equally adaptable to heavy impasto and fine-detailed techniques – as well as less prone to yellowing. Other oil-painting primers made with Titanium White, and alkyd-based primers are also available. Avoid all household primers, however, as these will endure for only a limited time before cracking.

Acrylic primings should never be applied over animal glue size. The glue expands and contracts according to humidity, while acrylic

primers, although they will flex with the canvas, will not contract. Applied straight onto stretched raw canvas, they dry thoroughly in only a few hours. Ideally, though, you should apply acrylic size first to impregnate the canvas surface to prevent any possible sinking of the priming coat.

Acrylic primers are described variously by manufacturers as acrylic, universal or acrylic gesso primers. The latter term is misleading as such a primer does not have the same absorbency as a traditional gesso ground prepared with animal glue and chalk. Acrylic primers are water-thinnable, durable and dry thoroughly to become water-insoluble. Ideally they should be slightly absorbent and not too shiny on the surface or the oil colour will not adhere to it properly. They can be applied direct to wooden panels and hardboard, which should be wiped first with methylated spirits to ensure that the surface is grease-free. This will aid adhesion.

▶ Cutting lights into
darks – defining edges
*Achieving precise lines or
clearly defined edges, as for
example the rigging lines in
marine paintings such as
David Curtis'* Sailing
Vessels, the William and
Wright Dock, Hull *(oil on
canvas, 510 × 610 mm,
20 × 24 in) can be a problem,
especially in paintings like this
in which the brushwork is
fairly loose and free. David
pulls the painting together at
the end, and defines shapes,
particularly rigging lines, by
cutting the colours of lighter
areas such as the sky, into the
darker lines, put in roughly
first with a No.1 brush.*

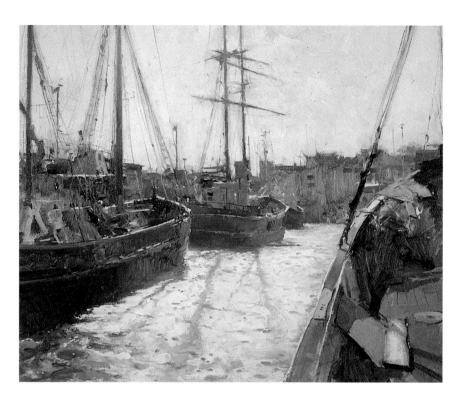

◀ Studio paintings
*Studio paintings often have a
more considered feel about them
compared with paintings
completed* alla prima. *The
procedure for artists like David
Curtis, who works in the
studio as well as on the spot, is
less frenetic; the painting can
be worked on over several days
– weeks, if necessary. More
paint layers can be built up,
and elements changed, taken
out or added in. His* Early
Morning, Southampton
Water *(oil on canvas,
610 × 1270 mm, 24 × 50 in)
was painted in the studio from
an on-the-spot oil sketch and a
photographic reference (for the
small boat on the left). The
brushwork is quieter and less
free than in* Sailing Vessels,
the William and Wright
Dock, Hull, *and the final
paint surface is more finished,
reflecting the peacefulness of
this early morning scene.*

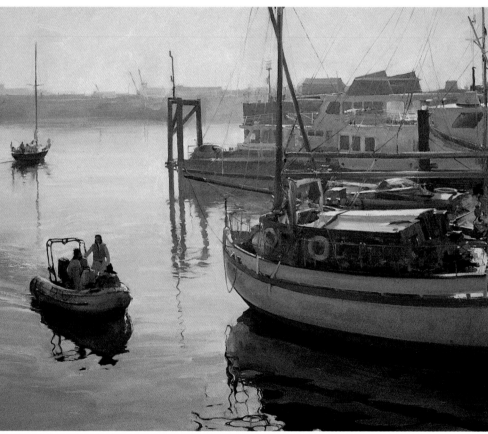

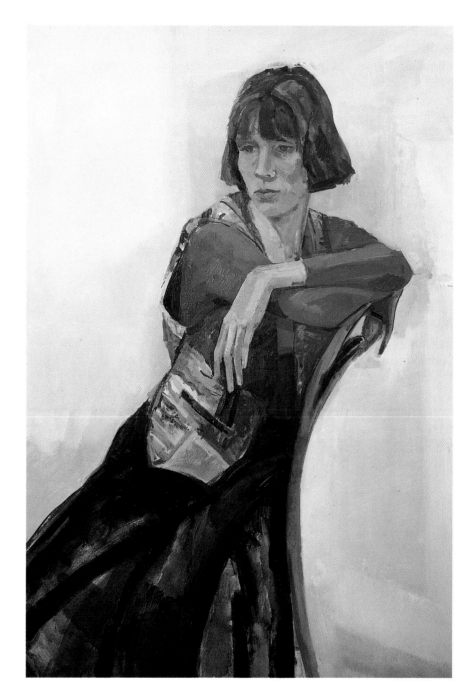

Brushwork

Brush strokes in oil paint remain clearly visible and can be exploited to evoke mood, suggest texture and describe form. It is worth spending time experimenting with different brush shapes and applying paint in different consistencies and on various supports to discover their possibilities and to find those most suitable for expressing what you want to say about a subject.

In Christopher Baker's **Hannah** *(oil on oil-primed canvas, 900 × 660 mm, 36 × 26 in) the artist has used a filbert-shaped brush like a flat to apply wedges of paint and to suggest the different surface planes of the subject's hair (see detail above).*

The speed at which the paint is applied is also important; note the difference here between the more gestural sweeps used to describe the skirt, the slower dabs on the face and the subtle blending of colour in the background. Brushwork is an artist's handwriting and it takes time to develop a personal style.

BRUSHES

Personal experience is the best guide to choosing the right brushes for your painting. Hog bristle brushes are most commonly used; their spring and resilience make them ideal for applying full-bodied oil paints to canvas-textured surfaces, although artists like Meg Stevens also use finer sable brushes for painting detail or blending colours. Synthetic brushes provide a robust and economical alternative. Long-handled brushes are generally preferred by professionals because they allow you to paint at a distance from the painting surface.

Choice of the shape of the brush head itself is usually determined by the style and stage of development of the painting. A short flat brush

MASTERCLASS
with David Curtis

A strong believer in working on site, David Curtis exploits the 'gutsiness' and buttery texture of oil paint to capture his subjects with an immediacy that he considers only achievable with this medium. He works in watercolours, too, because experience in both increases his scope and ability to deal with a wide variety of subject matter, but prefers oils for *plein air* work because he can 'get the subject down quicker'. He works with controlled nervous energy in front of his subject, applying colours wet-into-wet, manipulating broken colour effects, developing areas of impasto and cutting lights into darks to build his forms, sometimes rubbing paint out with a rag dipped in turpentine to make corrections in the early stages.

Transient light effects and different weather conditions, the subtle nuances of nature and more complex marine subjects with their jumble of man-made shapes and sparkling reflections in water, feature prominently in David's work. Figures, too, appear as incidental or sometimes more dominant elements. Underlying all his paintings, though, is a strong sense of design and composition, as well as sound draughtsmanship. His interest in design and drawing means that he usually selects a high horizon line which enables him to focus on the foreground features that lead the eye into the composition, and to concentrate on the light, weather and mood of a scene.

▶ Landscape above Goldsborough
oil on gesso-primed board
355 × 255 mm (14 × 10 in)
The clouds scudding across the landscape and the halo effect created by their partial obliteration of the sun gave David the opportunity to apply his paint with an immediacy and vigour that emulate the transience of this windswept scene. The cloud forms comprise three main tones scrubbed on with a square-edged brush before David diffused their edges with his fingers.

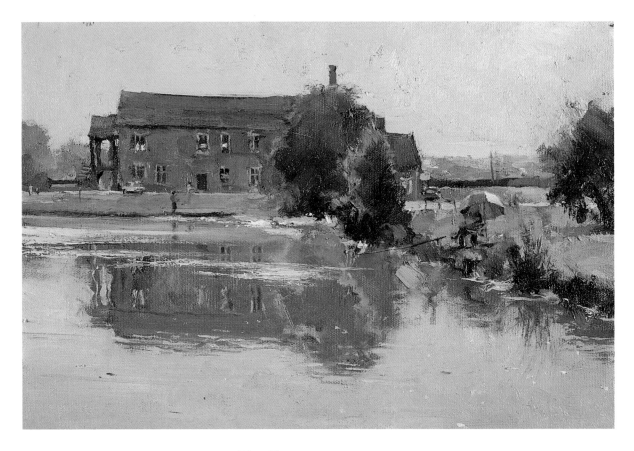

Fishing for Carp, Shire
Oaks
oil on board
255 × 355 mm (10 × 14 in)
David selected a biscuity-
toned board on which to
capture the hot, sultry
atmosphere of this quiet scene.
Carefully considered
interlocking blocks and areas
of colour – the blue band of the
horizon and the stone building,
for example – create the forms
and textures. Note the
demonstration here of how the
forms such as the roof are
defined by the final application
of lighter colours cutting into
darker areas of paint. The
water is a base of Titanium
White with small amounts of
Raw Sienna, Cadmium
Yellow and Cadmium Red.
This was put in last and cut
into the darker shapes.

THE ESSENTIALS OF COMPOSITION

The essence of extracting the magic from a subject depends for David on 'plucking out the best bits' in the few hours you have in front of the scene and in the area you select to paint. He uses his thumb and first finger of each hand to form a rectangle through which he frames and decides on his composition. This helps to develop an eye for a subject, to 'learn how to be selective' and to look for a composition that 'fits together in a drawing sense'. Thumbnail sketches can help here, although David now relies more on his experience to select the view that has the most potential. When the composition seems 'wrong', he says it is usually 'the positioning of the elements within the composition that's wrong. You pitch these too low or too high.'

To avoid such problems and to ensure a good compositional design, David stresses the importance of looking for features on the Golden Section and making sure that elements are not placed centrally and awkwardly in the composition: 'Get the essentials sorted out and the rest will take care of itself.' Note in *Fishing for Carp, Shire Oaks* how the placement of the horizon line on the upper Golden Section – one third of the way down from the top horizontal edge – means that greater importance is given to the foreground water and reflections; and note also the positioning of the fisherman placed one third in from the right-hand side on a vertical Golden Section.

As for most painters, other factors behind an effective composition for David include keen observation combined with simplification of the forms in a subject, and the quality

of the linear structure – the skeleton of the picture – underlying the over-all shapes, tonal pattern and colour of a work. This is clearly demonstrated by how he has managed to hold together the complex composition in *Moored Vessels, Hull Docks*, for example.

Moored Vessels, Hull Docks

oil on canvas-covered board 510 × 610 mm (20 × 24 in) David started by rubbing out the lightest lights from the initial biscuity-grey wash with a turpentine-soaked rag. The complexity and detail of the subject has been rigorously simplified and is underpinned by the curving, linear design of

the composition which forms a reverse snaking S-shape that leads the eye into and around the picture from the bottom right. The draughtsmanship – some of the drawing can still be seen – put down after the initial wash, is the key to this painting, which is painted with an immediacy and looseness that gives it its sense of spontaneity.

To help to simplify the shapes and tones in a subject David advises painting either early or late in the day when the tone, colour and atmosphere of a scene are intensified and easier to distinguish. Painting into the light, especially, also simplifies forms; dark and light areas become heightened, as in *Twin Bridges, Roche Abbey*. But he also points out the value of painting in flat light, which affords the challenge of painting with minimal contrasts of tone. It also gives you more painting time and allows you to relax and get to grips with the finer points of the subject.

Ultimately, for the sake of a really good design, he believes in making modifications to the subject to enhance a composition. As he says: 'Artists' licence is a unique facility' that should be exercised whenever the painting demands.

MATERIALS OF THE OUTDOOR PAINTER

For his outdoor work David generally uses an acrylic-primed hardboard, which he coats with a layer of gesso primer and texture paste, mixed in equal proportions to give the surface a little 'tooth'. For convenience he travels to painting sites in his camper van with up to ten boards of various sizes from 255 × 180 mm (10 × 7 in) up to 405 × 305 mm (16 × 12 in), each of which he prepares beforehand with various washes, some in a cool neutral tone of French Ultramarine and Raw Sienna, through to a warm tint of French Ultramarine, Raw Sienna and Burnt Sienna. This allows him to choose the most appropriate ground for his painting, according to the light and mood of his subject.

Twin Bridges, Roche Abbey
oil on board
305 × 405 mm (12 × 16 in)
David was inspired to tackle this subject, which he painted on the spot at the same time in the morning on two separate days, by the effect of the sun shining through the trees and foliage, and the rich reflections in the river. He worked frenetically in the first painting session, establishing the composition and broad tonal scale, before placing the shimmering highlit nuances in his second visit to the scene.

Moorings on the Dordogne

oil on board

305 × 405 mm (12 × 16 in)
The shadows across the green muddy water and occasional shafts of sunlight attracted David to this subject. He chose a board coated with a thin wash of Viridian on which to develop this on-the-spot painting, comprising essentially the tonal shift seen in the dagger shape of the light part of the water, the two shadows running across it and the darker bowls of the trees. The high horizon line means that he was able to concentrate on the water. The trees extend beyond the top horizontal edge of the painting, but the loose upward strokes of the brushwork generate a feeling of growth that avoids a stunted look. Note, too, the 'lost and found' diffused edges that characterize this work. The figures and boat add human interest and a sense of scale to · the painting.

David Curtis.

Alternatively, for high-contrast subjects that demand a 'rub-out' technique, as in *Afternoon Light, Runswick Bay*, David applies the initial wash *in situ* and uses a rag to wipe off the paint to indicate the lightest tonal areas.

Canvas-covered boards for working on outdoor paintings larger than 405 × 305 mm (16 × 12 in), to which he applies a further coat of oil-based primer to give the surface the 'dryness' that he likes, are also part of his 'travelling studio'; he carries a couple of stretched canvases, too, although he uses these mostly for studio work.

David uses Nos 1 and 2 short flat bristle brushes, which after a little wear offer him a convenient edge when the brush is used on its side. For finer points and impasto dabs he also uses acrylic brushes. He selects his artists' quality colours from different manufacturers' ranges and makes strategic use of quick-drying alkyd colours – Titanium White, Coeruleum Blue and Raw Sienna – to help speed up the drying process of his oils.

He is against too much thinning of the paint – except in the early wash stage – and makes only minimal use of turpentine as he likes the paint to be fairly 'dry'. This ensures a longer controllable painting time and avoidance of the unworkable 'creaminess' that can sometimes overtake a painting. Large quantities of rags on which he wipes his brushes, and a box-easel, as well as a pochade-box, for painting in the car in bad weather, complete his outdoor equipment.

RECOMMENDED PALETTE

For landscape painting David advocates the use of a limited palette of

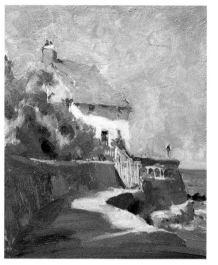

▲ 1 ▼ 2

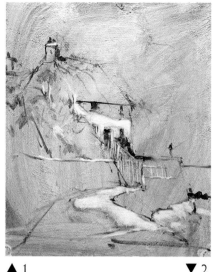

French Ultramarine, Coeruleum Blue, Burnt Sienna, Raw Sienna, Naples Yellow, Lemon Yellow, Cadmium Yellow, Cadmium Red, Cadmium Orange, Cobalt Violet, Viridian and Titanium White, because 'painting is hard enough without having to battle with your materials – you'll have enough problems with the subject.' He excludes Black and dye-based colours like Prussian Blue that are 'too insistent', and also warns against the use of other colours such as Neutral Tint and Vandyke Brown which 'are so hard for the student to use' and can lead to dull paintings that convey no sense of

Afternoon Light, Runswick Bay
oil on board
305 × 255 mm (12 × 10 in)
David primed a board with gesso and texture paste, then applied a fluid wash of French Ultramarine and Raw Sienna before mopping this with a rag to establish a uniform mid-tone for the painting.

After indicating the general compositional lines of this scene, to give a basic structural image from which to develop the painting, he next rubbed out the lightest areas where the sun hits the path and front of the building, down to the original white ground. The quayside provides an important visual lead into the house and fisherman on the horizon (1).

Working quickly with Coeruleum Blue, Raw Sienna and Titanium White, David brushed the sky area and painted the shapes of the building and darker green tones of the middle-ground trees and foliage, before blocking in the sea and foreground. He used Coeruleum Blue and Cobalt Violet to establish the near foreground shadows (2).

Loading the brush with some of the sky tone, David made final adjustments to the painting, including sharpening the structural edges of the building by cutting light paint into dark. The carefully positioned figure which breaks the horizon line and lends a sense of scale to the composition was loosely painted with touches of colour deftly applied with a fine brush (3).

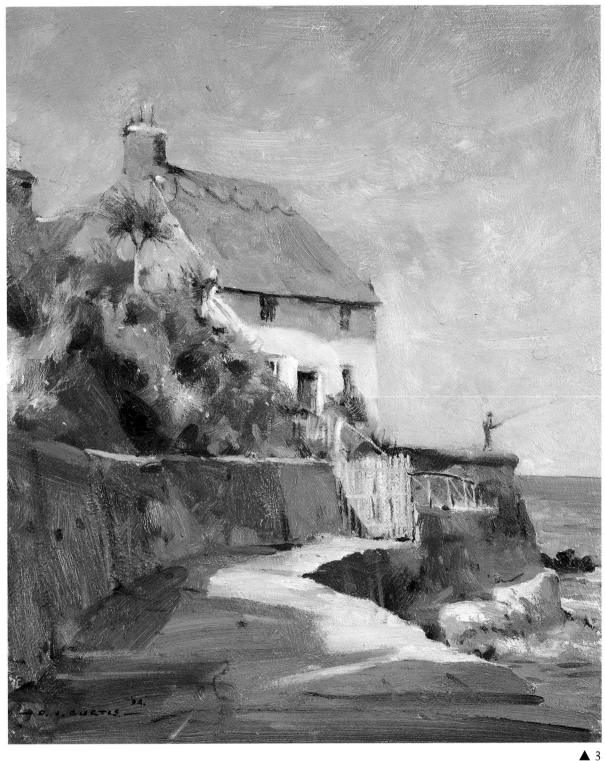

▲ 3

life. Selected colours like Monestial Green, which added to white creates 'cold lint yellows', and mixed with white and yellow 'gives you a vibrant green', are also introduced to his palette as required. He stresses, however, that his suggestions are personal and are not meant as ground rules as all colours have their place and uses.

David's palette is fairly high-key; often several keys higher than the

colours of his subject. Even his darks, for which he uses a mixture of French Ultramarine and Burnt Sienna, are not insistently dark, and because the paint contains little body colour they shine in his paintings. He advises against using body colour too early because, 'if you get everything massed in with no body colour, then you've got time on your side – you won't end up with a sea of "mud".'

OUTDOOR WORKING TECHNIQUES

Having selected the most appropriate board or surface, and ground, for his subject, and established the lightest lights in paintings in which he adopts his initial rub-out technique, David draws in the essential compositional elements of his scene fairly sketchily with his No. 1 short flat brush. For this he usually uses a mid-tone neutral mix of French Ultramarine and Burnt Sienna, or a mixture from the previous day's palette. Establishing the darkest darks becomes the next priority,

against which he is then able to gauge all the intermediate tones, working from the broadest facets first and concentrating on the whole painting surface area to ensure a sense of unity in the final work.

He applies his paint with frenetic intensity, scrubbing his colours onto the surface in the early stages with a passionate urgency that contributes a sense of dynamism to the finished painting. He feels it is important to 'throw caution to the wind'.

David's brush marks emulate the character of the forms to which they relate: skies, clouds and natural forms become fractionalized by his scrubbing technique, clearly demonstrated in *Landscape above Goldsborough*; a bank, or the roof of a building, are described with broad, horizontal strokes.

Subsequent stages of the painting process include adding high-key tonal areas and highlights, and 'pulling the painting together' by making some forms more definite, while leaving other areas generalized. David emphasizes the importance for him at this stage of 'cutting the lights into the darks' to

Sheltered Moorings, Woolwich

oil on canvas
255 × 355 mm (10 × 14 in)
David set up his easel in a car park to overlook this busy scene which offered him considerable scope in its compositional appeal. Essentially he saw the design of the painting as a series of blocks – tone against tone, the lightest area being the water. The curved forms of the boats contribute a sense of life and action to the work, which was completed on the spot in a single two-hour session.

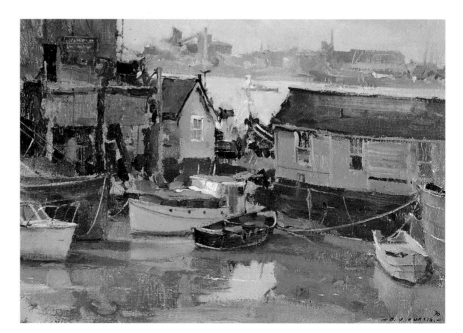

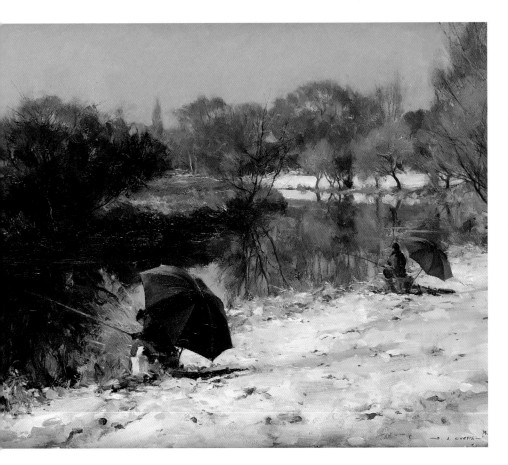

Bend in the River, Misson
oil on canvas
510 × 610 mm (20 × 24 in)
The illusion of three-dimensional form and space is generated in this painting by the use of counterpoint, by which an object appears dark against a light area, and vice versa. Note how this works in the delineation of the fishermen's umbrellas; their edges are defined light against dark and dark against light. The snow is the key to the success of this painting; it has simplified the shapes in the landscape, heightening the design quality of the picture, and has offered David the opportunity to exploit the subtle browns, ochres and purple-greys of this winter scene. The purple-grey background trees contrast starkly with the snow, but their colour is repeated in the play of shadows in the foreground, contributing to the unity of the composition. The fishing rods were added with a part-worn No. 1 short flat bristle brush, lightly held and using the side edge, with a minimum amount of paint.

control and make the compositional shapes more profound. For example, in *Fishing for Carp, Shire Oaks* you can see how the roof shape has been more concisely defined by a horizontal stroke of the lighter colour of the sky 'cutting into' this darker area. As a result of this technique he does not have to worry too much in the early stages about the precision of details such as telegraph poles or rigging lines because, 'when you bring a broad brush of a lighter colour into either side of a darker shape, you can create as thin a line as you like. Don't fiddle, and never try to paint darks into lights or you will make a complete hash of your painting.'

Finally, once the painting is thoroughly dry, David applies a coat of retouching varnish which helps to 'rescue' the darks if they have dried too matt.

ADVICE TO THE OUTDOOR PAINTER

For the inexperienced painter David suggests that the most useful piece of advice for painting *in situ* is to think simply about the subject, and to paint small: 'Take a little piece of the landscape in the middle distance. This will simplify the subject for you because you won't be able to see too much detail. See the pattern and design in the subject and keep it simple.' Ultimately, he believes that the results of what you do are directly commensurate with the amount of effort you put in to your painting, and that the key is to 'paint what you see, not what you think you see. Forget it's a tree or a figure; see landscape elements as blocks and shapes and remember that it is as much what you don't say that matters.'

MASTERCLASS
with Colin Hayes

Colin Hayes' paintings of Greek and Spanish landscapes, in which his aim is to 'make the colours explain the space and atmosphere' of a scene, are imbued with a sense of the simple, abstract design that he looks for in a subject. A key part of this process is his simplification of the horizontals and verticals in a view, which gives his compositions a strong feeling of geometry. But it is the vibrant colour in his paintings that strikes the greatest chord. As you can see in the painting *Landscape in Evvia, Greece*, his work is about sunshine and colour, which he invites us to celebrate and enjoy. And it is because he is so interested in colour that he prefers to work in oils – although he may often start a painting in acrylics for convenience – since they provide him with 'a wider means of expression, particularly in terms of colour and chromatic intensity'.

▶ *Pencil and watercolour sketch for* Landscape in Evvia, Greece
165 × 195 mm (6½ × 7¼ in)
Generally, Colin selects subjects in which he can explain the sense of space through his use of colour rather than linear perspective. Of all the paintings reproduced here this, and the oil painting for which it is a study, are perhaps the clearest examples of this interest. You can see how his written note on the left of the study, that the trees in the background 'recede to violet', for example, has been emphatically developed in the oil painting.

Landscape in Evvia, Greece

oil on canvas

760 × 1015 mm (30 × 40 in)

If you half-close your eyes this painting becomes almost an abstract design of light and dark shapes crisscrossing the painting diagonally. But the subtle shift of colour values throughout the composition, from the warm deep greens in the foreground, through to cooler greens in the middle distance and finally to the violet passages in the background, creates a sense of recession into the far distance that is almost purely dependent on colour. The change in scale from the larger clumps of foliage in the foreground, to the smaller brush marks in the background, also contributes to the sense of distance. The vertical lines in the foreground and middle distance punctuate and link the various elements of this panoramic scene. Again, the sky is as deep in tone as many of the greens; the landscape is lit instead from behind us.

*Pencil and watercolour study
for Lepoura, Evvia,
Greece*

*125 × 180 mm (5 × 7 in)
In this sketch you can see the
artist's interest in seeking out
the 'design' that underlines and
joins together the various
elements in the scene — and the
colour relationships, noted in
many places in pencil. Note,
too, his indication of the trees
and foliage in terms of broad,
simple shapes, which in the oil
painting become passages of
colour rather than literal
descriptions of the objects that
they represent.*

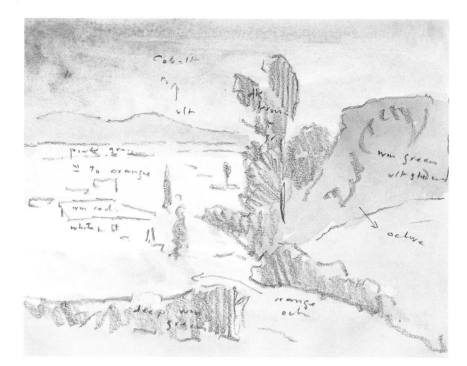

Colin Hayes.

PRELIMINARY WORK

A favourite source of landscape subjects for Colin is the island of Evvia in Greece where he owns a cottage, and where he is inspired by the light and bright colours. Here, he explores the countryside for places to paint, usually settling on a subject for a morning session and another one for the afternoon when the light is different.

Once he has found a view that combines an interesting underlying design, light effects and spatial organization, he makes precise statements in pencil drawings and watercolours about what excites him in the subject. On these he often writes notes about the colours in a scene, as in the studies for *Lepoura, Evvia, Greece* and *Landscape in Evvia, Greece*, for example. His preliminary work provides him with accurate information about what goes where, the proportions, the tone, and the general design, which he 'sticks to at all costs' in the oil painting. As he says,

a danger, especially for inexperienced painters, is the tendency to try to make the first idea 'more polite' by tidying up the initial 'sketch'. On the contrary, he advises against the concept of 'sketching'. For him accuracy about an aspect of the subject is crucial in the early stages. He believes that it is important to have something firmly fixed around which everything else will 'slot in', and although you may 'enrich, embellish, modify' or make the first idea 'more subtle', he warns against simply trying to make it more 'acceptable' because 'you'll bore yourself from the start'.

SUPPORTS, GROUNDS AND PRIMING

For smaller-scale paintings, and for convenience when working abroad, Colin generally likes to work on linen canvas which he pastes to a hardboard panel with an ordinary artists' glue-resin. For larger-scale

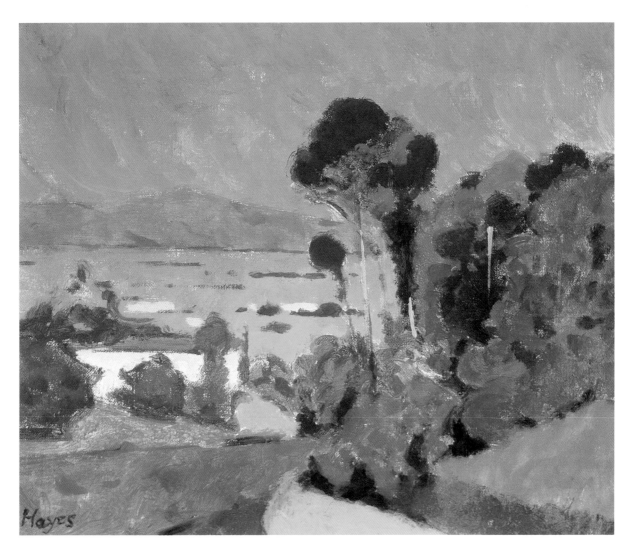

paintings he works on stretched canvases, preferably raw linen, which he prepares himself, or if he is in a hurry he may buy ready-stretched cotton canvases, in which case he re-primes them to ensure a good working surface.

He is diligent about the preparation of his painting surfaces. If he is feeling 'really conscientious' he will cold-size a linen canvas first by applying an initial layer of rabbit-skin glue with a squeegee. This 'helps to get rid of the hairy texture of the canvas'. This is followed by three *thin* layers of Titanium White primer; the first brushed on, the second two applied with a squeegee. He emphasizes the importance of

applying your priming thinly in several layers, rather than in just one thick layer, to avoid the risk of cracking later on. Alternatively, he applies up to two thin coats of acrylic primer followed by several coats of acrylic Titanium White, in which case he can work more quickly by starting in acrylics before developing the painting in oils.

MATERIALS

Colin selects his artists' oil colours from various manufacturers' ranges, and prefers to prepare his own oil-painting medium, consisting of dammar and stand oil, or sun-dried

Lepoura, Evvia, Greece
oil on canvas
255 × 305 mm (10 × 12 in)
Simplification is the overriding principle behind Colin's paintings. Here you can see clearly how he subscribes to the belief that you should never try to draw or paint what you cannot count. So, instead of trying to paint every leaf, or blade of grass, the trees and foliage are suggested by their translation into passages of subtle greens, ochres and purples and overall shapes that fit into the main design.

linseed oil and turpentine. As the painting progresses, he reduces the amount of turpentine in his medium and finally relies just on the oil in the tubes, adhering strictly to the principle of working from lean to fat. The use of dammar in his medium is important for helping to speed up the drying time of his paints and for enhancing the matt quality of his painting surfaces. It also helps to 'keep the colours up'.

Colin mostly uses long round hog brushes, sizes Nos 1 to 10, because he likes their versatility and because 'with a hog you have to be more abstract and reinvent, whereas you are more likely to try and imitate what's in front of you with a sable' – which is why he advises students to 'cut their teeth' on hogs. However, he does find sables useful for making preliminary marks on a canvas to indicate the initial compositional design. Large house-painter's brushes are also useful to him for priming canvases and laying in foundation colours on larger-scale works. He prefers not to use a palette knife for scraping back colours because for him painting is about 'putting on, not taking off colour'. And, crucially for a painter whose overriding interest is in colour, 'it also tends to reduce the whole key of a painting'.

PAINTING TECHNIQUES

Having established the vertical and horizontal structure underlying and connecting the different elements in a landscape scene, Colin starts working with oil colours as soon as possible, either directly onto a pre-pared panel on the spot, or a larger stretched canvas back in the studio, referring to his preliminary notes in the first instance.

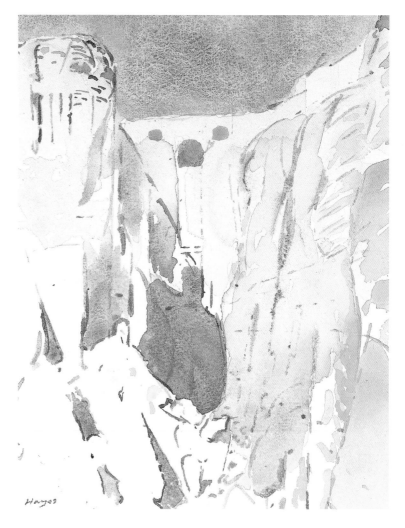

Watercolour study for
Ronda, Spain
225 × 180 mm (9 × 7 in)
This study demonstrates how in his preliminary work Colin first looks for and indicates the main verticals, horizontals and diagonals, as well as the major areas of dark and light. Comparison with the oil painting of this subject shows how closely he sticks to his first idea in the developed work.

The subsequent development of a painting consists for Colin of constantly modifying his colours as he progresses from an initial warm Light Red or Terra Rosa underpainting over a bright white canvas – crucial for ensuring the luminosity of his colours – through to cooler hues. To achieve this he scumbles thin paint across the canvas surface, keeping things broad and simple in the first place and avoiding making too many different kinds of tonal statements. His initial interest is in establishing one or two main colour relationships, around which he will make other colours 'fit' to occupy their correct place in space. As he is most concerned at this stage to get the warm and cool passages working, he might even lay in a thin, transparent scumble of a warm colour complementary to the cool one that will go on top in order to achieve the required final vibrancy.

Essentially, Colin's technique relates to Sickert's description of oil painting as being similar to the effect created by throwing down ten playing cards from a pack (symbolizing the first layer of paint), followed by more cards, until there are several layers of cards (or paint) through which you can still see

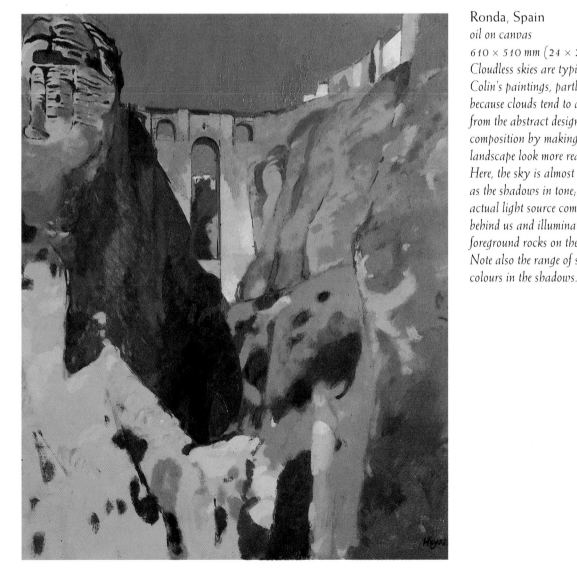

Ronda, Spain
oil on canvas
610 × 510 mm (24 × 20 in)
Cloudless skies are typical of Colin's paintings, partly because clouds tend to detract from the abstract design of a composition by making a landscape look more realistic. Here, the sky is almost as dark as the shadows in tone; the actual light source comes from behind us and illuminates the foreground rocks on the left. Note also the range of subtle colours in the shadows.

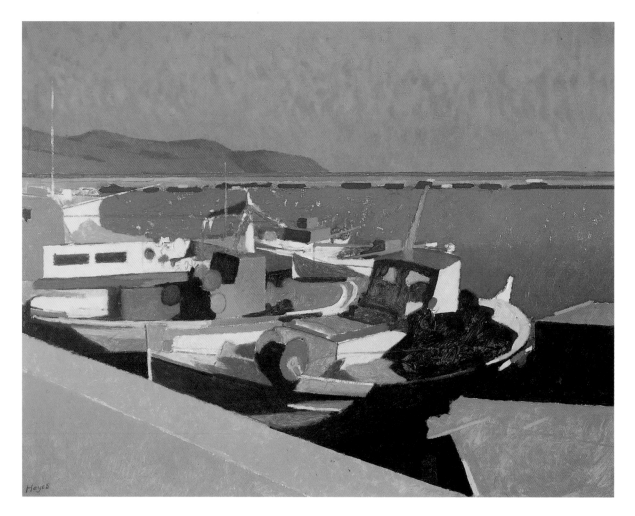

▲ *Photographic reference for*
Karistos Harbour, Greece
Colour transparencies such as this 35 mm shot of this harbour scene are occasionally used by Colin for reference purposes – but only as a supplement to his studies made on the spot.

facets of the first layers. This principle is clearly demonstrated in the sky in *Karistos Harbour, Greece.* Working wet over dry is, of course, fundamental to this working procedure and a painting will typically take several weeks to complete.

TONE AND COLOUR

The 'clean' vibrant quality of the colours in Colin's paintings – note even the shadows in *Karistos Harbour, Greece*, for example – is the result of careful manipulation of his colour values. As he explains, 'there is no such thing as a "dirty" colour in itself if it's the right value – it's a matter of what's round it, what *works*.' The achievement of

▲ Karistos Harbour, Greece
oil on canvas
710 × 915 mm (28 × 36 in)
Warm pinks and violets break through passages of blue towards the horizon line in the sky area, showing clearly Colin's technique of building up and modifying areas of colour, allowing colours underneath to show through and influence those on top. This also shows how he sometimes scumbles on a thin layer of a colour complementary to the one that will go on top to increase the vibrancy of his colours.

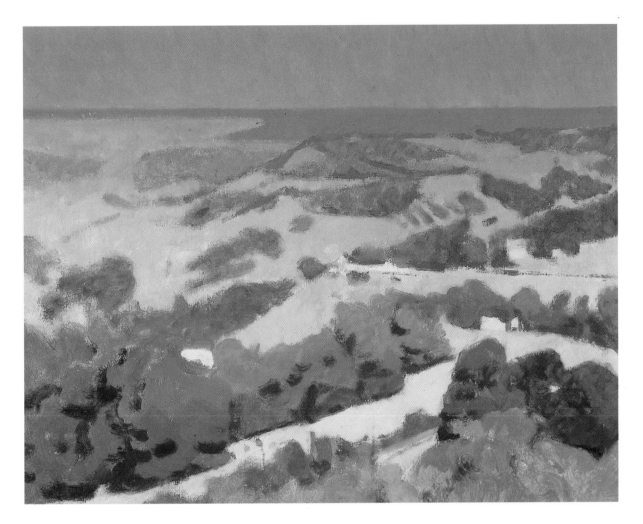

brilliant colour lies, as Colin points out, in reinventing and getting the pattern of tones right, which is not just a question of black, white and grey because different colours will make tones with different apparent values of light and dark. Another problem that inexperienced painters often have is that they are not aware enough of the effect of complementary colours – that the apparent value of a colour depends on the colour next to it, especially if it's a dark or grey colour – a modified colour – which will take on some of the complementary of the bright colour next to it. Colin's paintings are absolutely dependent on his understanding of this principle. So although his colours are not necessarily local colours and there-

fore consistent in a literal sense with those in the view in front of him, because they work tonally they successfully *explain* rather than *describe* the space and atmosphere of a scene. This is especially clear in *Towards Evvia, Attica*.

To get to grips with this principle Colin advises students to get into the habit of comparing dark with dark, half tone with half tone and light with light, rather than dark with light which is so obvious that you never really come to understand the subtle differences between one dark and another.

Colin's palette is not rigorously defined, partly because he does not wish to be restricted from achieving a particular colour pitch by not having the most suitable one available.

Towards Evvia, Attica
oil on canvas
355 × 455 mm (14 × 18 in)
As in Landscape in Evvia, Greece, *here the sense of distance is evoked almost entirely by the use of subtle shifts in colour, from the bright warm greens and ochres in the foreground, to the cooler grey-purples in the background. We are also persuaded by the artist that between us and the distance in this painting there is a great deal of atmosphere and air that modifies the colours and values in the scene.*

Colin Hayes' typical landscape palette. From top left, clockwise: Flake White, Coraille, Cadmium Red, Rowney Rose, Rouge de Pouzzolles, Yellow Green, Cadmium Green, Alizarin Green, Vert Cinabre Foncé, French Ultramarine, Cobalt Blue, Hoggar Blue, Ivory Black, Hoggar Blue and White mixed, Mauve Red Shade, Rowney Rose and Alizarin Green mixed, Coraille mixed with Mauve and White, Rouge de Saturne, Cadmium Yellow. The four colours in the middle of the palette are mixtures from those around the outside.

Included amongst his colours are Cadmium Yellow and Orange, and a wide range of greens, because although these are not predominant in his paintings, 'they are useful for arriving at other colours'. He also uses French Ultramarine, Cobalt Blue and Hoggar Blue, a brilliant blue which is useful for 'bumping up' colours towards green. Coraille, a coral orange, is more red than Cadmium Orange and useful for warming up browns without lightening them. Other good working colours for him include the earths, Yellow Ochre and Light Red, and he uses Ivory Black for making colours warmer or for neutralizing them. There is no pure black in his paintings, however, and on the whole he advises against its use: 'If a shadow colour is too light, start again – don't add black because then you're not really thinking about the colour you want to arrive at; you're only thinking about making it darker.'

Colin mixes his colours on the palette and for each particular passage in a painting he will mix up two or three blobs of colour and compare their value on the palette before committing them to canvas.

Contrary to his own approach to colour Colin advises inexperienced painters to start with a limited palette, however; then to master tone and the difference between warm and cool colours. He also notes that 'it's a good old precept that you should try to avoid an equal amount of warm and cool colours in a painting', a principle to which he generally adheres in his own work.

PICTORIAL STATEMENTS

For painters interested in landscape painting Colin emphasizes the importance of looking for a subject with 'pictorial possibilities that will turn itself into a statement' rather than a 'picturesque' view. And he advises against 'getting involved with the impossible, such as tangles of brambles in the foreground!' Most importantly, he points out that you should choose a subject that excites you and decide to stop when the painting is still working tonally and in colour value and when it has said what you originally intended to say about the subject. After all, as he points out, 'you can't paint the ultimate painting – there's always something else to be said, so move onto another painting rather than continue by painting another painting on top.'

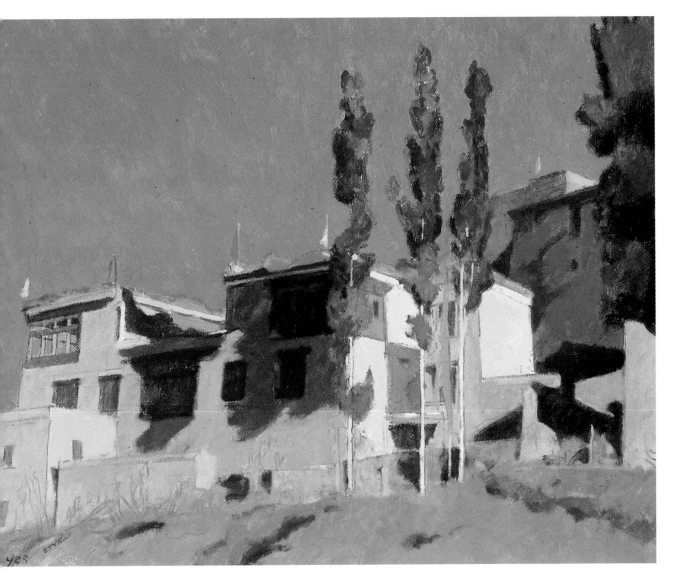

Tibetan Farmhouse,
Ladakh
oil on canvas
710 × 915 mm (28 × 36 in)
*Ladakh, the Indian part of
Tibet, has also been a favourite
source of subject matter for
Colin. As it is so high – over
3,500 metres up – and
hundreds of miles from the
nearest smog, the air is pure
and the colours clear – ideal
for a painter who thinks
predominantly in terms of
colour. The intensity of the
light hitting the sides of this
farmhouse is almost palpable.*

MASTERCLASS
with Ken Howard

Ken Howard's paintings are a celebration of the coruscating effects of sunlight. He is inspired to paint a subject by the way strong light defines its shapes, forms, composition and mood. Cityscapes, beach scenes, figures against the light, and situations in which the quality of light is a predominant feature attract him. Throughout his work Ken's passion for expressing the effects of light through his tonal organization of colour is evident. By manipulating the mid, light and dark tones, he enhances the subtle glow of his colours so that his paintings seem to transmit their own intense light.

He works in both oils and watercolours and has a great desire to break down the technical differences between the two media. His studio oil paintings, in particular, reveal how he exploits the individual characteristics of oil paint to full advantage and applies watercolour-like techniques to the medium to achieve the stunning light effects for which he has become well known. In these large-scale canvases he lays in thin scumbles, interplays translucent glazes with opaque buttery-texture paint, scrapes off when necessary, makes use of broken colour effects and applies final glazes to bring back colours that may have sunk. The variety of surface textures that this produces enlivens the brilliant light in his paintings and adds impact to his compositions.

▶ Two Blue Kimonos
oil on canvas
610 × 510 mm (24 × 20 in)
For this work Ken used the same model for both figures, working out the composition first and painting the same figure twice, in two separate painting sessions.

A sense of light predominates and is expressed by the transparent yellow of the fan in the window, the yellow highlight catching the background model's breast and top of the middle-ground box, the transparency of the parasol on the floor and the powerful tonal relationship between these areas and the mid and dark tones. Note the sketchy, impressionistic handling of the fairly thin paint, counterpointed by the opaque flecks of Coeruleum Blue on the kimonos, which act as visual keynotes in the painting.

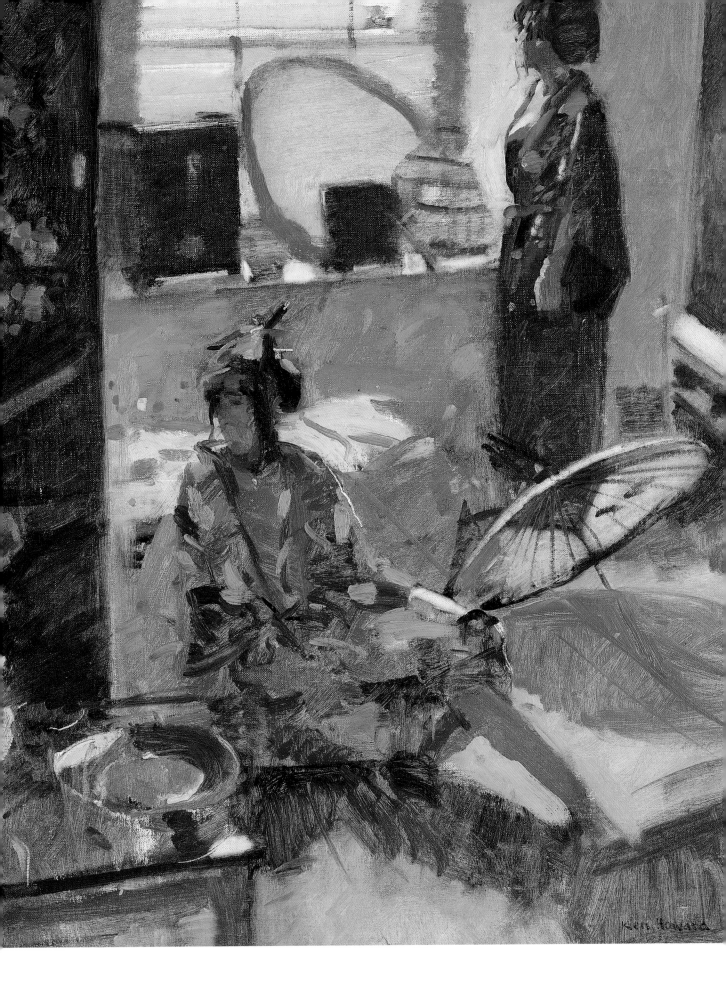

Sennen Cove Beach

oil on board

205 × 255 mm (8 × 10 in)
Ken painted this on-the-spot panel standing on the beach, looking into the light and up to the car park wall, which forms the dark backdrop to the activity in the middle and foreground. The stunning effect of the bright sunlight through the windbreaks against this dark wall is created by the tonal contrast between this background area and the mid-tone of the beach, and the final lighter-tone touches. The painting technique is rapid and direct; the paint is comparatively even in consistency and the forms are expressed in broad dabs and touches. The shapes of the figures are only suggested, but are convincing nevertheless. The composition is simple in its stress on the relationship between the horizontals and verticals – a compositional theme that runs throughout Ken's work.

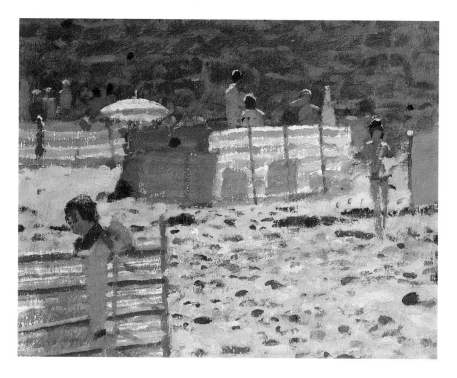

WORKING *ALLA PRIMA*

Ken's working practice and the supports on which he paints differ according to whether he is working *alla prima*, or in the studio. For oil paintings completed on the spot, such as *Sennen Cove Beach*, he prepares his own panels, usually at the beginning of each summer, by buying around 100 various sizes of hardboard from 205 × 255 mm (8 × 10 in), up to a maximum of 405 × 510 mm (16 × 20 in) (no larger 'because you can never finish if your boards are too large'), each of which he covers with fine muslin, sized onto the boards with rabbit-skin glue.

He applies a proprietary oil-based canvas primer to form his ground. A very simple, but useful tip for the travelling painter that Ken finds especially helpful when he paints abroad is to stick matchsticks on the back of his panels, one in each corner. This enables him to pack them one on top of another in a suitcase, and transport wet paint-ings home again, protected in the middle of the stack.

A sturdy box-easel, at which he stands to paint, carries his brushes – a selection of filberts up to size 5 or 6 – paints, palette, white spirit, jam jar, rags and, surprisingly, a ruler. This helps him to draw in his horizontal line, which he likes to establish first to show the proportion of sky to ground in his compositions before starting the painting.

His working technique for an on-the-spot painting such as *Piazza Della Campo SS Annunziatta, Florence* is direct and rapid. Once he has isolated his subject in his mind, established his horizontal line and scumbled on a mid-tone coloured ground, he suggests the main groupings in broad brush strokes, adjusting and pulling together the mid, dark and light tones until he has expressed his subject to his satisfaction, usually in up to two-hour sessions.

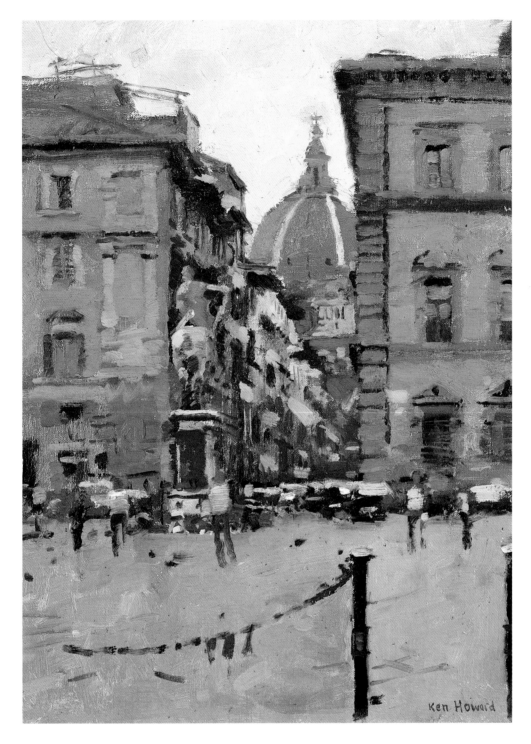

Piazza Della Campo SS
Annunziatta, Florence
oil on board
405 × 305 mm (16 × 12 in)
Like Sennen Cove Beach
this was painted on the spot in
one session lasting
approximately two hours.

Again, the painting relies for
its simplicity on its
horizontal/vertical structure;
note how the vertical of the
right-hand building is picked
up and continued down
through the foreground
gatepost. The eye is led from

the quiet area of the foreground
square down the street that
leads to the background dome,
which in its dominant curved
shape provides a visual
counterchange to the strong
horizontal/vertical emphasis of
the composition.

Watercolour study for **Midday Light, Ghanerao** *240 × 295 mm (9½ × 11½ in) This on-the-spot watercolour study, made during a visit to India, provided the compositional information for the studio oil painting of the same subject. Once back in London, Ken squared up a large section of the study and transferred its basic compositional structure onto a larger canvas.*

STUDIO MATERIALS

For his studio paintings Ken uses ready-stretched linen canvases, to which he applies an additional white ground to eliminate any 'greasiness'. To get rid of its whiteness he either adds a colour to the ground before applying it, or he rubs a transparent scumble of thinned Raw Umber, or Burnt Sienna, over the ground once it has dried, with a rag.

He sometimes adds a ready-prepared painting medium consisting of linseed oil and turpentine to his colours. At other times he uses an alkyd resin, which is good for glazing because it dries more quickly, or occasionally he uses turpentine on its own.

Ken paints mostly with hog hair flats and filbert brushes – never riggers – and uses watercolour sable brushes for 'pulling the drawing together', and sometimes for putting on glazes. These are larger than those used for his panel paintings, and include a 5 cm (2 in) housepainter's brush for large areas. He advises working with as large a brush as possible for the size of painting to help you to avoid the temptation to 'fiddle'. He prefers square-edged brushes because for him oil painting is about putting down mosaic-like facets of paint which merge to make a reality once you stand back from the painting. As he says, 'I don't think you should stir around or torture paint too much.' A palette knife is used for mixing his colours on a traditional kidney-shaped palette, and occasionally for spreading large areas of colour onto the bigger canvases, or for scraping off.

STUDIO PRACTICE

Ken's studio paintings vary in approach according to the subject matter he is painting. For the large

1220 × 1525 mm (48 × 60 in) studio interiors he usually tries out the composition on a smaller painting first (610 × 510 mm, 24 × 20 in), and then expands and develops it on the larger scale once he is satisfied that it will work. Others, such as *Two Blue Kimonos*, are painted direct, in a manner similar to his *alla prima* work. For more complicated compositions, such as *Midday Light, Ghanerao*, or when working on the spot for several hours is impossible, he might square up a working drawing or watercolour completed on the spot, at which stage he likes to establish the horizontal and vertical 'architecture' of the composition.

Midday Light, Ghanerao
oil on canvas
1015 × 1220 mm (40 × 48 in)
Ken's main concern in this studio painting was to achieve the right colour and tonal relationships to express to full effect the intense light of the scene, captured in the small watercolour study, while still retaining a sense of overall harmony. To achieve this he added Raw Sienna to the wall behind, because this area was too cool at one stage in contrast with the street, and for the same reason he added some of the grey-blue colour of the walls to the road. The result is a painting that through its warm/cool, light/dark relationships recreates the strong sense of light that inspired the artist, but which remains harmonious because similar colours are repeated throughout the composition.

By comparison with the *alla prima* paintings, studio compositions such as *The Emma Triptych* are larger, more 'consciously' painted over a longer period of time – often weeks rather than hours – and display a far wider range of paint techniques from thin glazes to thicker impasto and opaque colour. These show the important influence of Ken's watercolour painting (he paints in watercolour for around one-third of the year) on his oil technique. In *Two Blue Kimonos*

Ken Howard.

The Emma Triptych
oil on canvas
1220 × 1220 mm (48 × 48 in)
This is Ken's contemporary version of the panels and altarpieces seen and admired during a visit to the Accademia in Venice. He used the same model posed in front of the window in his studio for each canvas, and painted each at the same time of day – between 9 a.m. and 10 a.m. – when the sun was behind and striking from the left. The right-hand canvas is bathed in shadow, while the left-hand canvas is illuminated by warm light. Starting with the middle and left canvas, Ken worked on these, followed by the middle and right canvases, then all three together as the triptych progressed.
Originally a piece of fabric occupied the foreground space, but he later replaced this with the painting table which helps to pull the light – the main subject of the work – down to the bottom of the painting.

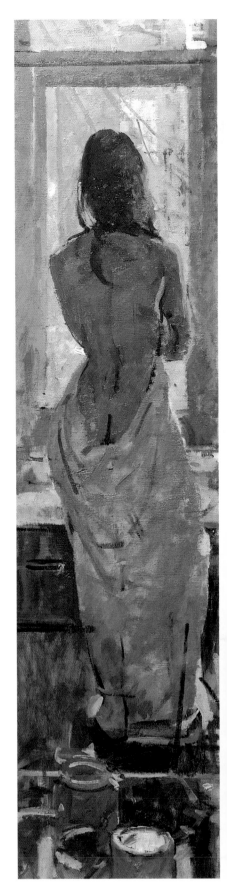

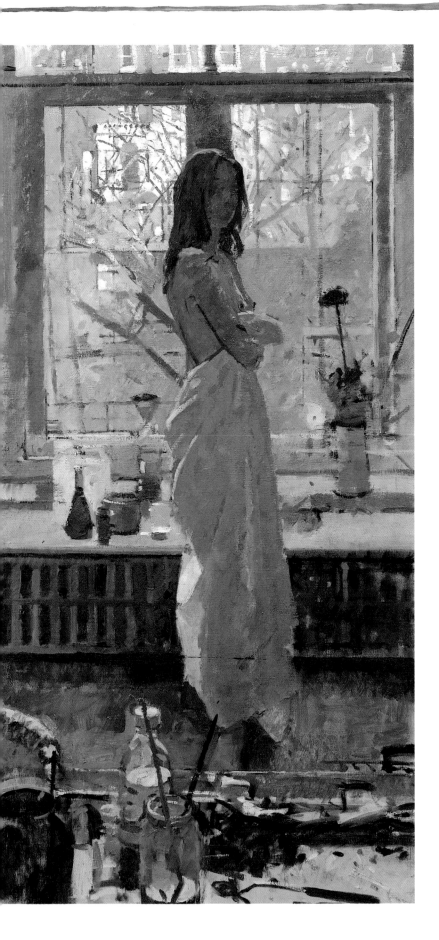

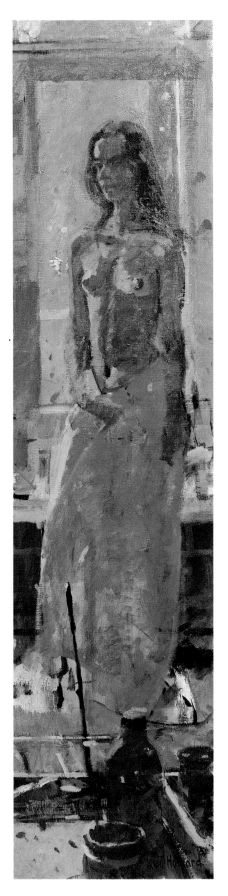

you can see how he delights in the texture of the paint by playing transparent glazes against more impasto opaque colours, underlining his aim to 'bring my oil and watercolour technique closer together. There is no need for one to be thought of as an opaque medium and the other as a transparent one.'

A TONAL PALETTE

Ken stresses the importance of working with a limited palette, especially for inexperienced painters, 'because this really teaches you something about colour. You've got to get the effect you want by the relationships *between* colours.' Currently his basic studio palette is based on earth colours and comprises Raw Umber, Yellow Ochre, Raw Sienna, Burnt Sienna, Naples Yellow, Blue

Black, White, and possibly Indian Red, although if he finds himself becoming too familiar with a particular palette he will break it down and introduce other colours. He uses Naples Yellow for lightening his colours rather than White, which he likes to put off using for as long as possible: 'If you introduce White to your colours too early the final painting will tend to look very chalky.'

The subject also dictates his choice of colours. For example, for on-the-spot beach paintings such as *Sennen Cove Beach*, which was painted in bright sunshine, his palette comprised: Aureolin and Lemon Yellow, a little Yellow Ochre; Crimson and Cadmium Red; Coeruleum and Ultramarine Blue, Cobalt; and Raw Umber, 'a good binder which introduces harmony to the palette'.

Late Afternoon Light
oil on canvas
1525 × 1830 mm (60 × 72 in)
To evoke the sensation of light that inspired this large-scale composition, Ken has made the overall painting comparatively low in tone. The sensation of light is enhanced by the low sulphurous green tone of the beach and the contrast between this area and the key points of the windbreak and red and yellow sail in the distance. Note that although the figure sitting gazing out to sea looks as though he is wearing a red shirt, its colour is in fact Burnt Sienna – it looks red only because of the amount of Blue Black surrounding it.

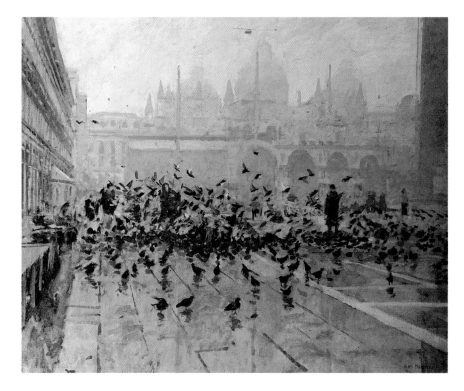

Rain, Mist and Pigeons,
S. Marco, Venice
oil on canvas
1015 × 1220 mm (40 × 48 in)
*Very different from his usual
brightly lit subjects, Ken was
moved to paint this scene by
the magic of the mist, which
brought all the colours close
together, creating a dramatic
contrast with the dark shapes
of the figures and birds.
As he has painted the subject
many times before, he relied on
his memory of the scene for this
studio painting, as well as a
photograph of the moment that
the birds took flight. On the
infrequent occasions when he
uses photographs to rekindle
the initial stimulus, as here,
Ken prefers to use black and
white pictures as they provide
better tonal information than
colour prints.*

Colour harmony is especially important to Ken. Sometimes he may add an odd, discordant note to a painting to give it life, but overall his aim is to 'pull everything together', which is why he pays particular attention to the tonal balance of his colours. For this reason he mixes three or four basic values on his palette – the darkest, middle and lightest tones – and then feeds colours from the perimeter of his palette into these blobs of paint to warm or cool them as required.

LEAN TO FAT: DARK TO LIGHT

Underlying all his work is a strict adherence to some of the fundamental principles of oil painting: that you should work from lean to fat, and from thin darks to thicker lights. As he notes: 'When you start a painting, always paint it "down", then pull it through by lightening it; never try and paint it up and then darken it.' Of course, with experi-

ence, this process becomes instinctive, so that when Ken starts an oil painting he automatically puts down his darker colours, letting the canvas act as the half tone. Then, to establish the placing of his lights, he will often put some of these down as well to see if they will work, before scraping them off again with a palette knife. In fact, at one stage he used to like working on a pure white ground, which enabled him to lay in his darks, and then use a rag to rub and pick out the lights: 'Then I'd have the half tones and darks and lights picked out, which really sang.'

A PROCESS OF ADJUSTMENT

As for most artists the development of a painting is a process of constant adjustment for Ken; of keeping the whole picture working tonally at all stages. As he says: 'Composition isn't pattern making.' Each part must be right in itself – for

Emma and the Painting Table

oil on canvas

710 × 915 mm (28 × 36 in)
Initially this painting comprised just the play of light through the window on the foreground still life, which occupied two-thirds of the composition. However, because the artist felt that this was not enough for him as a subject, he dropped the still life down in the painting and added the figure. This meant a great deal of scraping back with a palette knife and readjustment as the painting developed. The subject is still the play of light through the window, expressed predominantly by the interplay of tonal contrasts throughout the objects on the painting table, but the figure adds a human element and provides an area of warmer colour in an otherwise fairly cool painting.

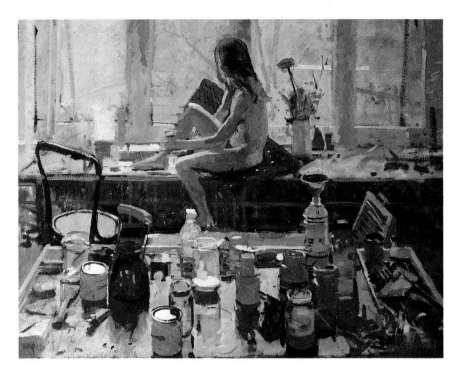

example, the tone of the top of the tin in the foreground still life in *Emma and the Painting Table* works in its own right, but also in relation to the tones around it and in relation to the whole, helping to express the sense of light falling on the foreground objects.

Losing and redefining the edges between areas of colour is also part of this process of adjustment, which in the studio paintings means scraping down with a palette knife from time to time. Sometimes, too, he will 'rub paint off with turps and start again'. Similarly, he might 'tonk' his paintings on board ('which you can't scrape because if you do you'll lift all the paint off'). All these procedures are an important part of Ken's technique because they take off any superfluous paint, leaving in place the initial image and ensuring that the painting is touch dry for the next day's session. This allows him to apply scumbles and glazes of colour over thin, dry paint with no danger of the paint cracking later on.

It also means that he can exploit broken colour effects more extensively than in the *alla prima* paintings, which by contrast are completed in 'one wet', because he can paint wet over dry, and use drybrush techniques to introduce a greater variety of paint-handling methods to enhance his shimmering light effects. Note, for example, how the drybrush-scumbled sulphur blues in the area outside the window in *The Emma Triptych* contribute to the sense of light emanating from this work.

Indeed, when Ken feels that he has fully captured and expressed at least something of the sensation of light which excited him about the subject in the first place, a painting is finished for him. The fact that objects, such as the radiator in *Emma and the Painting Table*, are not developed to a highly detailed finish, is immaterial, as long as their shape, tone and texture contribute to the overall sensation of light that he seeks to capture and express in all his paintings. He advises that

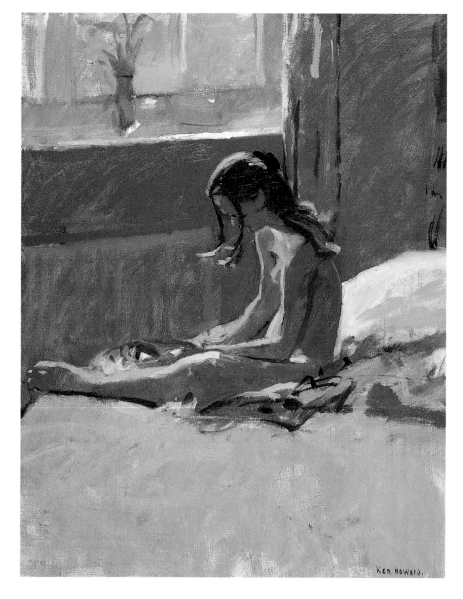

Emma Contemplating
oil on canvas
305 × 255 mm (12 × 10 in)
COURTESY OF MANYA IGEL FINE ART
Although on canvas, this was painted in one rapid session direct from the model as she was sitting on a bed in front of a south-facing window. The paint is thinly scumbled and the design almost abstract in its simplicity. A sense of quiet repose predominates, enhanced by the gentle colour and warm light picking out the model and illuminating the bed.

you should always stick to your first stimulus and not allow anything to distract you from it as the painting develops.

ACCIDENT AND INTUITION

The freshness, coruscating light, and apparent freedom of approach in Ken's paintings, belie the control and adherence to ground rules that underpin his work. As he says: 'Painting is about having certain ground rules that you work within; but it is also about being able to recognize when an accident has worked.' He goes on: 'You must learn what you are doing first, by practising constantly, before painting becomes intuitive. My aim eventually is to paint as much as possible, with as little as possible, and as directly as possible.' The apparent simplicity of a painting such as *Emma Contemplating* is a testimony to this ambition.

Ken Howard's painting table.

MASTERCLASS
with Ben Levene

en Levene appreciates the 'juiciness' of oil paint and the 'richness' of oil colours. The advantage for him of using oils over other media lies in the fact that you can go on finely tuning the painting until you 'get it right', although he also strives to keep a painting 'fresh'; as he says, it is important not to overwork the paint surface. The key to his work resides in the tension that exists between the appearance of his subject and the abstract elements of the painting – the space, design and colours of the composition – and the way the paint expresses its tactile values.

His aims are twofold: he seeks to achieve an immediacy that comes from the recognition of the identity of the objects in his compositions and the visual impact of the shapes and colours, together with a timelessness that derives from the gradual discovery of subtleties unfolding in a painting each time you look at it. This quality is fundamental to all types of painting and all subjects for him, and is probably the hardest to achieve.

Ben became more involved with still life as a motif through teaching and setting up groups for students to work from in his part-time classes at Camberwell School of Art in the 1960s and 1970s. As he says, the still-life motif is an art form within an art form because you are re-creating in a painted composition a world which you have already arranged aesthetically by your selection and placing of objects. Perhaps more than any other subject still life allows you to work directly from the subject, go away, come back and pick up the threads of the picture and carry on; in addition it challenges your picture-making skills.

▶ Statice New Art Shades
oil on alkyd-primed hardboard
810 × 710 mm (32 × 28 in)
The bright colours of the flowers inspired this composition and Ben has played these against the subdued colours and simple shapes of the surrounding pictorial elements in order to emphasize their vibrancy. Although the basic geometric areas in the foreground and background appear at first glance to be flat shapes of colour, these have in fact been overpainted with many thin glazes of colour to create subtly modulated areas that have a tension of their own. This is important for making such areas 'work' with the main subject of the picture.

Table of Surprises
oil on alkyd-primed hardboard
865 × 990 mm (34 × 39 in)
Ben's interest in this picture
focused on counterbalancing
the quieter areas such as the
background, which anchors
the composition, with the busy
area of foreground objects and
geometrically patterned rug.
The overall muted greys and
browns of the background
picture are punctuated by the
brighter yellow lemons, which
provide a point of focus. Note

how Ben has carefully
described the three-
dimensionality of objects such
as the decorated bowl, and the
spaces between the still-life
elements, so that we barely
notice that the surrounding
areas are picture-making
abstractions with only a loose
basis in reality, and which act
as a foil to the still-life subject.

INTERPRETING THE SUBJECT

In effect setting up a still life for Ben is like making his own landscape and he can spend many hours selecting and arranging his objects to arrive at an interesting combination of shapes, colours and rhythms, which he 'distils' from the subject into a two-dimensional design.

Not everything becomes translated into an abstraction, however. Ben is also keen to describe the solidity of some objects – for example, the bowls in *Table of Surprises*,

so that they look real and you feel you can pick them up – to counterbalance the less tangible, abstract elements in the picture. It is important, as he points out, to remember that painting is a 'double-edged world' of real objects combined with abstract design.

To achieve 'areas of importance' in a painting he will also leave out some of the decorative detail on a carpet, or a rug, to make quieter areas as a counterpoint to the 'busier' parts of a painting. In addition a mirror, placed behind or to the side of a group of objects, can help to set up complex real and reflected abstract shapes, some of which are selected to interplay with the real space and objects in the foreground, as in *Still Life with Japanese Vase.*

Taking such liberties is an important part of translating the subject into a pleasing two-dimensional composition, but Ben stresses that this must always arise from the actual process of painting the picture. His approach to a still-life subject is similar to that of a portrait painter in his aim to achieve a likeness; to describe how things exist with, and in relation to, each other. On the other hand, the creation of an exciting new object – the painting – depends on the creative licence that he exercises during its development. This evolves from his involvement with the painting and depends on artistic judgements that are based on years of experience.

Still Life with
Japanese Vase
oil on alkyd-primed hardboard
865 × 965 mm (34 × 38 in)
Ben especially liked the composition suggested by this arrangement of objects and the pictorial 'arch' described by the dried acanthus and its reflection in the mirror.

The reflected shapes in the background, including the dark area of the reflection of the studio window of the night view outside, are simplified to create a geometric framework which holds the rhythms within the painting together. The strong verticals contain the composition within the picture edges and interplay with the curves and diagonals of the objects and space in the foreground. As in Table of Surprises, *Ben has used an area of strong yellow to provide a visual anchor.*

SUPPORTS AND GROUNDS

Durability is important to Ben, so although he likes the sensitivity of working on linen canvas, which he stretches and primes himself, the vulnerability to damage of stretched canvases in exhibitions means that he more often uses hardboard, or medium density fibreboard, on a small enough scale (a maximum of 965 × 865 mm, 38 × 34 in) to avoid the necessity for battening. The criterion he uses is that the board has to be rigid.

Crucial to him, too, is the careful preparation of his supports. As he says, you get a real feeling for your materials by preparing them your-

self. When working on hardboard he first sandpapers the smooth side before applying a coat of rabbit-skin glue, followed when dry by a priming layer of lead-white primer, or an oil-based alkyd primer. He also enjoys working on a gesso ground, which provides a good base for his gold- and silver-leaf paintings. He makes his own gesso by mixing chalk whiting with rabbit-skin glue size and applies up to seven layers over the initial layer of size to form an absorbent and 'beautifully velvet-like' surface. This must be sealed with a weak solution of rabbit-skin glue size before painting to prevent too much oil from the paint sinking into the ground causing

Bromeliad Vreisia
*oil on alkyd-primed hardboard
840 × 965 mm (33 × 38 in)
The vibrancy of the red flower
against the subtle, grey
background dominates the
upper part of this painting. In
the still life itself this area was
a mirror, but Ben simplified the
composition by painting it out,
along with its mirror-images,
to concentrate on this colour
relationship and the definition
of the shapes of the leaves. As
in many of his other paintings,
the shapes in the carpet design
have been simplified and
abstracted, while the detail on
the plant pot has been clearly
defined. On the other hand, the
glass decanter is merely
suggested by its silhouette
because it is a background
element and must not distract
our attention away from the
pot and flower. These are
typical of the kinds of
decisions that Ben has to take
into account in all his
still-life paintings.*

dullness to the colours, while still permitting a degree of absorbency.

Sometimes he adds pigment to the final layer to make a toned ground. A touch of Indian Red mixed into the white gesso makes a 'delicious Italian pink' (this forms the basis for *Vermilion and Gold*); or the addition of Raw Umber makes a biscuity tone. On oil grounds he may wipe a wash of diluted colour onto the primed surface to give it a transparent tone before painting. In each case the whiteness of the initial ground layer is important for ensuring that the subsequent oil colours 'hold up'. It also contributes a luminous quality to the transparent colours.

Choice is a factor here, too. Ben sets aside time to prepare his painting supports and grounds so that when he comes to painting a particular subject – he paints about twelve to sixteen pictures each year – he can select the most suitable size and appropriately prepared (white oil-primed, gessoed, or coloured ground) surface.

COLOURS AND MEDIUMS

Ben selects his colours from different paint ranges, and for economy always buys the largest tubes available. He restricts himself by limiting his palette to only a few colours, which 'can give a feeling of strength to a painting; it also teaches you to mix colours.' Typical limited palettes might be Flake White, Yellow Ochre, Light Red, Cobalt Blue, Burnt Umber and Ivory Black; or Titanium White, Cadmium Lemon Yellow, Venetian Red, Monestial Blue, Raw Umber and Mars Black. Limited palettes such as these are strictly adhered to as a working discipline.

Alternatively, Ben starts some paintings with an idea about economy of colour, but allows the subject matter to dictate which other colours are to be introduced, in which case he may also use Ultramarine, the earth reds and various greens. Often, such compositions end up by being painted with about sixteen to twenty colours. There are no set rules for Ben when he starts a painting. There is, as he says, an 'interplay between the painting going its own way and me trying to direct it in some way'.

Although his tutor, Sir William Coldstream, used to insist on students at the Slade (where Ben studied from 1956 to 1961) mixing their colours on the palette until they are 'right' for the painting, sometimes Ben mixes his oil paints on the

Vermilion and Gold
oil and gold leaf on pink gessoed hardboard
560 × 480 mm (22 × 19 in)
To compete with the gold leaf, Ben exaggerated the strength of the colours of the carpet where it meets the gold background. This foreground presented many difficulties for him. Although the pink of the gesso ground seemed to work well with the background and pot plant, he was worried by its apparent simplicity. He worked on it further with thin glazes of pink paint, complicating it to excess before overpainting it to return this area to its initial simplicity.

Glitz
oil and silver leaf on gessoed hardboard

760 × 560 mm (30 × 22 in)
The use of the shape in the background as a perspectival spatial device is typical of Ben's still lifes. Its inclusion here helps to suggest the illusion of recession into depth, reinforced by the relationship of the smaller, mirror-image of the pot plant with the larger object in the foreground. The unusual sense of space in this painting is arrested by the powerful, flat, light-reflecting silver-leaf background, which brings the viewer's eye back to the foreground.

The composition is dominated by the impact of the relationship between the bright pink flowers, the icy blue cloth and the dazzling silver-leaf background of the painting.

canvas. He also might end up putting a colour intended for a particular area somewhere else on the painting. It is important, as he stresses, to be prepared to improvise: 'Nothing is ever right until it's finished – everything is in a state of flux until you decide not to work on a painting any further.'

To keep things as simple as possible, when he works on an oil-primed board at first he adds only pure turpentine or white spirit to thin the paint, and as the painting progresses he introduces a proportion of linseed oil to the mix, adhering here to the principle of painting fat over lean. As he says, you get an instinctive feeling from the paint as

to when this is necessary; it all depends on the pigment used and the absorbency of the ground. He usually ends up painting with 40 per cent oil mixed with 60 per cent white spirit.

For painting on the more absorbent gesso ground he usually starts off with stand oil diluted with turpentine or white spirit to help prevent the colours from sinking too much in the early stages of a painting. Additionally, stand oil enhances the durability of the paint film and increases the transparency of colours, making it an ideal glazing medium, which Ben exploits to modify his colours in the later stages of the painting.

Rock Carnations
oil and gold leaf on gessoed hardboard
815 × 705 mm (32 × 27¼ in)
Ben selected, omitted elements and played around with his subject in response to the demands of this picture. The gold-leaf background suggests the presence of the mirror in front of which he set up his still-life objects and we can identify mirror-images of the bowl, glass, vase and rug. The reflection of the carnations is omitted, however.

The painting is dominated by the complex interplay between the geometry of shapes such as the ellipses of the glass, and the rhythms and patterns set up by the objects and spaces between them. Some elements are played down, others exaggerated; the final success of the picture depends on the strength of the painted image, which exists as a new object in its own right.

The vibrancy of the red carnations, the initial inspiration for the picture, is emphasized by Ben's use of Cadmium Red and its relation to the gold and grey colours around the flowers.

GOLD-LEAF PAINTINGS

For his gold- and silver-leaf paintings Ben's procedure is affected by technical considerations. He uses gold or silver leaf to create powerful backgrounds which reflect the light and contribute a majestic, jewel-like quality to the painting. These areas must be tackled first. So, once he has drawn out the structure of a composition on the gesso ground with a brush in tempera paint and established more or less where features are going to be, he applies a red or yellow bole (base covering) to the area to be covered in gold or silver leaf. He then gilds this area, exploiting the breaks between the leaves to add a textural quality to the painting. Once the actual painting is under way he might come back to distress an area behind a particular form more than another, to help to make it appear to recede in space. A final layer of wax protects this delicate gold surface.

BRUSHES

Good brushes are paramount for Ben because 'if you use inferior brushes they won't have the sensitivity to make the marks you want – and I need all the help I can get!' Larger, long-handled hogs (No. 10 or 12) are used for broad areas of

Wedding Posy
oil and gold leaf on gessoed hardboard
610 × 510 mm (24 × 20 in)
The challenge for Ben in this picture was first to gild the background and paint the flowers in his friend's wedding posy as quickly as possible before they died.

The gold-leaf area provides a powerful background which, like a mirror, reflects the light and sets up an emanating golden glow. The grey shape at the base of this background area repeats the shape of the rug on which the posy stands, linking the foreground and background planes. This pictorial device is used in many of Ben's still lifes.

Ben Levene.

colour; he likes filberts because they do not leave a definite edge, and sables allow him the option of drawing fine detail.

PRE-PLANNING

Ben does not make preliminary sketches, but decisions such as how to structure the composition, where the ground plane should be, the placement of the still-life objects within the picture format, and which part of the painting to tackle first, must be made initially. These decisions can be influenced by the simple fact that cut flowers have a short life and must be painted in

first with some urgency before they change and die, as in *Wedding Posy*. For other paintings in which pot plants are a major feature, this is less of a consideration and he may start with a larger area such as the foreground plane.

BUILDING UP TONE AND COLOUR

Ben enjoys the challenge offered by the powerful visual quality of the gold or silver leaf to make the entire composition strong enough not to be dominated by it. He works on the rest of the painting, or on paintings without gold-leaf backgrounds,

with thinned paint and builds up depth of tone and colour by over-painting glazes and layers of opaque colour during separate painting sessions that may span several weeks or many months. As he says, 'with experience you learn how to layer paint without churning up underneath layers – which is what beginners tend to do.' The absorbent gesso ground helps to speed up the drying time of colours 'so you can float colours on top the next day without too much disturbance'. The final surface quality of his paintings is reasonably even so that the viewer concentrates on the design and is not distracted by the tactile quality of thick, gesturally applied paint.

His handling of paint is carefully considered as he seeks to 'draw' the shapes of his subject with his brush, and to create the illusion of space by the juxtaposition of tone and colour. As he comments: 'You are dealing with space. Painting isn't just copying something; it's translating three-dimensional things into a flat space.' Flat areas of colour are nevertheless modelled and modulated either to create the suggestion of three-dimensional form (as in the vase in *Wedding Posy*) or to add surface variety to a broad colour area, as in the background to *Evening Rose*.

FINISHING AND FRAMING

Knowing when to stop is crucial, 'otherwise a painting can become overlaboured'. This can be difficult, however, even for experienced artists. Ben admits that he does not always know what is wrong with a painting and with some 'it's a real struggle to know where I'm at in them.' He adds, 'Some paintings

seem to suggest so many options you don't know where to go next with them; others are more easily resolved.' The important thing is to maintain the courage to 'push the painting on'. As Ben says, 'You may not have a very clear idea about the conclusion, but you are working towards one.'

Finally, after about nine months and when a painting is fully dry he varnishes it for protection, and frames it himself. He considers this an important part of creating an object for display in people's homes, but warns that 'you mustn't carry on painting the picture in the frame'. Nevertheless, as he says, inexperienced painters especially should remember that 'bad frames can kill a picture while good frames can improve them'.

Evening Rose
oil on alkyd-primed hardboard
965 × 810 mm (38 × 32 in)
Ben kept the colours in this painting low-key to enhance the glow of the red roses. The simple background was built up by many glazes and scumbles of thinned paint to create a gently modulated area that provides a foil to the intricate pattern of the shapes and spaces between the leaves and the rich colour of the roses. The composition is anchored by the foreground horizontal lines. The low-key colours and undefined areas give this painting a mystic quality.

AN ENGAGEMENT WITH THE SUBJECT

The subject of landscape painting provokes intensely important issues for David. He began working directly from the Malvern Hills landscape in watercolours and drawings, and enlarging on the ideas extracted from this process in his oil paintings, after he retired from teaching in 1986. The motivation for doing so is inspired by factors such as his childhood memories of the hills, his environmental concerns, which he relates to his own mortality, and by his belief that we are better able to understand ourselves by looking at the nature of the environment in which we exist.

For this reason he researches the geography, social history, climate, agriculture, literature, music, painting, and individuals associated with the Malverns, and that is why he often uses quotations from A. E. Housman's poetry, for example *The Lofty Shade Advances*, *Air of Other Summers*, and *Nadir Roll*, as titles for his paintings because, as he says, Housman 'offers acute observations' of the area.

In addition, he records his thoughts in a journal, which helps him to articulate what he does in the studio. He believes firmly in the importance of research and the written word in helping the painter to deal with content as well as the practical and technical aspects of drawing and painting.

WATERCOLOUR SEQUENCES

David also spends much time walking in the hills in all seasons and times of day, filling pocket-sized sketchbooks with hour- or day-long watercolour sequences, recording places along a walk, or events in time at a single place as in *Black Hill, Malvern, Autumn*. These offer him a sequential record of the kind of information that then becomes 'synthesized' into an oil painting.

Black Hill, Malvern, Autumn

This pocket-sized sketchbook watercolour sequence records different views and angles of Black Hill during an autumn walk in the hills. Sequences such as this one may then become 'synthesized' into a studio oil painting; they also help David's visual recall.

DRAWINGS AND TOPOGRAPHICAL STUDIES

Larger (560 × 865 mm, 22 × 34 in) topographical watercolour studies completed on site, or partly on site and in the studio from other studies, such as *Summer Hill Prospect*, help him to 'fix' in his mind the images of the hills. As he says: 'The more work you do, the more you get back in terms of visual recall.' He also makes reed pen drawings on the spot, such as *South View, Summer Hill*.

RANDOM BEGINNINGS

Although working directly from the subject is important for the topographical studies, David's approach to his oil paintings starts from the premise that painting is about dealing with colour on a flat surface, which you 'energize' in your own particular way, in his case to reconstruct a sense of light and space. *The Lofty Shade Advances*, for example, is an invented semi-abstract aerial view of the Malverns, based on his knowledge of the hills, but painted without reference to any particular study.

He starts a painting on cotton duck, which he stretches and primes himself. He then applies washes of transparent colour thinned down with oil varnishes or resins, in an almost random manner, usually until the canvas is completely covered with colour. In effect this is a continuation of the initial preparation of the canvas, until he begins to see what he can make of it. Sometimes a painting will then be put to one side, to be continued later, possibly after being turned around to suggest new possibilities or approaches.

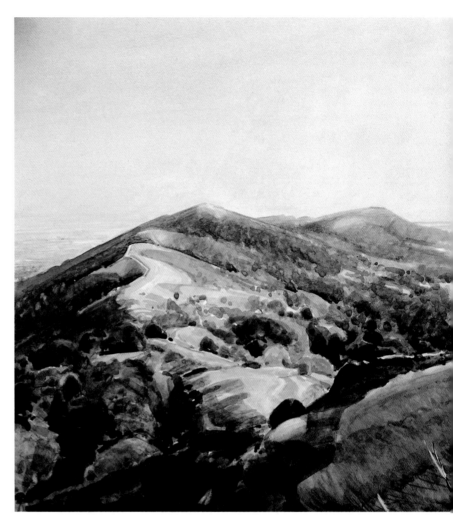

▲ Summer Hill Prospect,
1993
watercolour
560 × 840 mm (22 × 33 in)
This composite work is typical of the watercolour studies that inform rather than act as direct references for David's oil paintings. He painted the top part from an on-the-spot sketchbook study, and the foreground from another sketchbook painting. Note the similarity between this 'view' of the hills and the composition of Air of Other Summers *(page 87), and the link between the transparency of his watercolour technique with his use of thin glazes in his oils.*

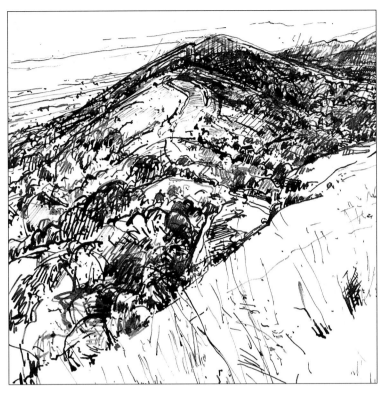

▲ South View Summer Hill, *1993*
reed pen drawing
280 × 280 mm (11 × 11 in)
PRIVATE COLLECTION
David's on-the-spot reed pen *drawings relate closely to his oils. In both his approach is to make marks that suggest, rather than describe literally, the characteristic elements of the Malvern Hills.*

▶ *David Prentice uses a steel tube construction easel designed especially for large-scale canvases by an art school colleague. His tubes of paint are arranged on open shelves to the left of his easel; a glass palette, jars of pigments, brushes and mediums are placed on a trolley to his right. Other paintings at various stages of development hang on his studio walls, while his watercolour and pastel work is done in an adjacent studio.*

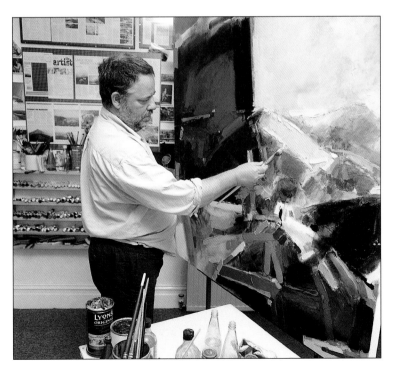

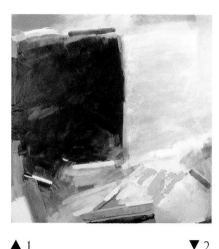

▲ 1

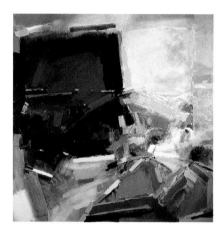

▼ 2

Nadir Roll, *1989–94*
oil on canvas
1475 × 1475 mm (58 × 58 in)
Inspired by his discovery in 1989 of iridescent acrylic colours, David started this painting by applying experimental glazes on the right-hand side of the canvas. Next, he painted the left-hand side dark, intending to base and develop the painting on a simple abstract theme of light and dark. At this stage the painting had no direct reference to an external source. It then went into storage (1).

Brought out again in 1994, David decided to change the theme of the painting to an exploration of the tonal division of the Malvern Hills into light and dark as you look along the ridgeway. His concern now became to construct a positive form in the centre of the painting to suggest that of a hill. Note at this stage the pale green slabby areas of colour down the right-hand side, which David later eliminated to open up the composition; here they act like a framing device to the right of the hill (2).

Over the next few weeks David applied more thick, opaque slabs of colour and transparent glazes of paint, defining and redefining forms, creating a more complex tonal structure and placing echoes of similar colours throughout the composition. Note that the right-hand panel of pale green slabs has now disappeared and how he has begun to balance the top-left dark area by adding darker slabs in the bottom-right area. This now balances the composition more effectively and helps to create the sense of moving into the painting from bottom right to top left (3).

Chance plays a vital role. So, although he may have a rough idea about a theme he wants to develop in a work – the idea of night and day in *Nadir Roll*, for example – the actual process of painting and what happens on the canvas informs his decisions as a painting progresses. As for most artists the process for David is a continual balancing act between his response to the painted surface and maintaining a clear sense of the initial idea.

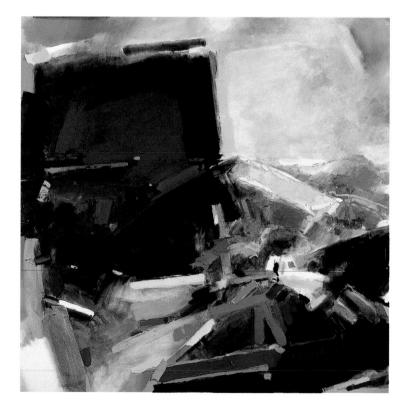

▶ 3

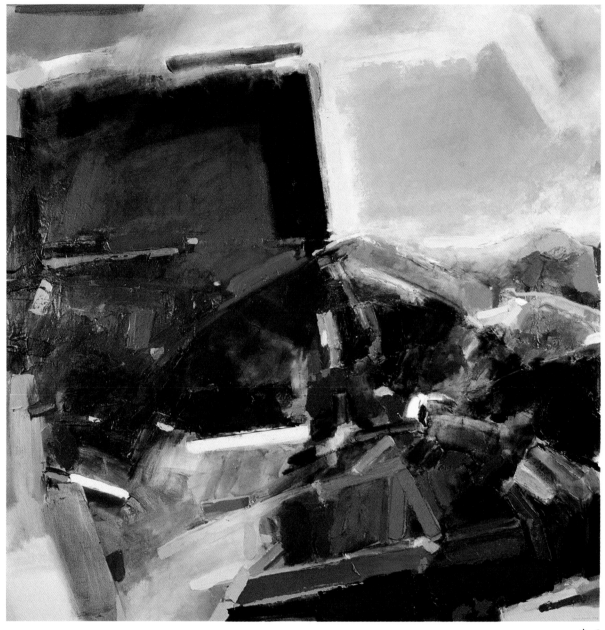

▲ 4

In the final stages David continued his practice of simplifying by glazing and varnishing, before recomplicating the composition by adding more brush and palette-knife marks. The resulting visual jerkiness of the forms in the bottom right corresponds to the rough physicality of the landscape to which it relates. Note the upturned V-shape in the 'foreground', which suggests a pair of legs walking across the landscape – a device that appears in many of his paintings (4).

For this reason David loves to work on top of old canvases, as in the case of *Nadir Roll*, or on old paintings that he strips first with a heat gun. In these cases he often allows some of the stripped areas to play a part in the work on top. In *English Air*, for example, the top left-hand corner is almost untouched after being stripped back from a previous painting.

MATERIALS AND MEDIUMS

An important advantage of oils for David is that they allow him to make dramatic changes to a painting over a long period of time. He works on his canvases slowly, often sitting back to look at them and sometimes spending hours simply moving colour about with his finger. All kinds of implements are used to apply his paint during this process. Slabs of colour are often palette-knifed on – he has half a dozen of different kinds – and he also uses a wide variety of brushes ('the shape doesn't matter as long as they're the right size'), rags, and, of course, his hands.

He mixes his colours and mediums on a glass palette, which allows him to control the thickness, transparency and surface finish of a colour. Each mixture and mark made on a painting is carefully considered. He believes in 'leaving what you've done and not mucking about with it too much – you shouldn't overwork a painting.' If a colour or glaze does not work, however, he will palette-knife it off or apply another colour on top once it is thoroughly dry.

A wide range of paints and mediums is important to David, because 'the bigger the range, the more provoking it is'. He uses fluorescent scene painters' pigments mixed with resin, 'which make amazing, delicious glazes', iridescent acrylic colours, and 'every kind of tube of oil paint I can think of'. Oilbars are useful for 'drawing' with colour, and he also draws on his paintings by applying paint straight from the tube. Of the various mediums he uses, a commercially prepared resin helps to make his colours transparent and slightly glossy, and speeds up their drying time. He adds wax to this medium when he wants to make his colours transparent as well as thicker. He also uses mixtures of dammar varnish and stand oil to add gloss.

ADDING WAX

To achieve the matt surfaces that act as counterpoints to the more glossy colours, David uses wax, which allows him to 'wallop' a colour on fairly thickly and makes the paint dry more rapidly. He warns, though, that 'you have to be careful about not making it so thick that it dries and slides across what's underneath it, if that's still wet.' The addition of distilled turpentine to the melted-down beeswax, which he buys in block form and softens in a saucepan, helps to 'keep it like furniture polish'.

Experience informs David's decisions about what to use to paint, in what mixtures, and when. Too much wax or resin will dilute the intensity of colour, for example. Different drying times, too, makes the process of painting as much about technical logistics as realizing your initial idea. He believes that technical experiment must be based on a firm understanding of the traditions and principles of accepted painting techniques.

English Air, *1993*
oil on canvas
1675 × 1220 mm (66 × 48 in)
Like The Lofty Shade Advances, *David developed this painting on top of another composition which he first stripped back to its first layers of colours with a heat gun. He was interested here in the effect of a vertical format on a landscape composition. A sense of looking into the distance from a high viewpoint is helped by the vertical structure of the darkest tones arranged on the left-hand side of the painting.*

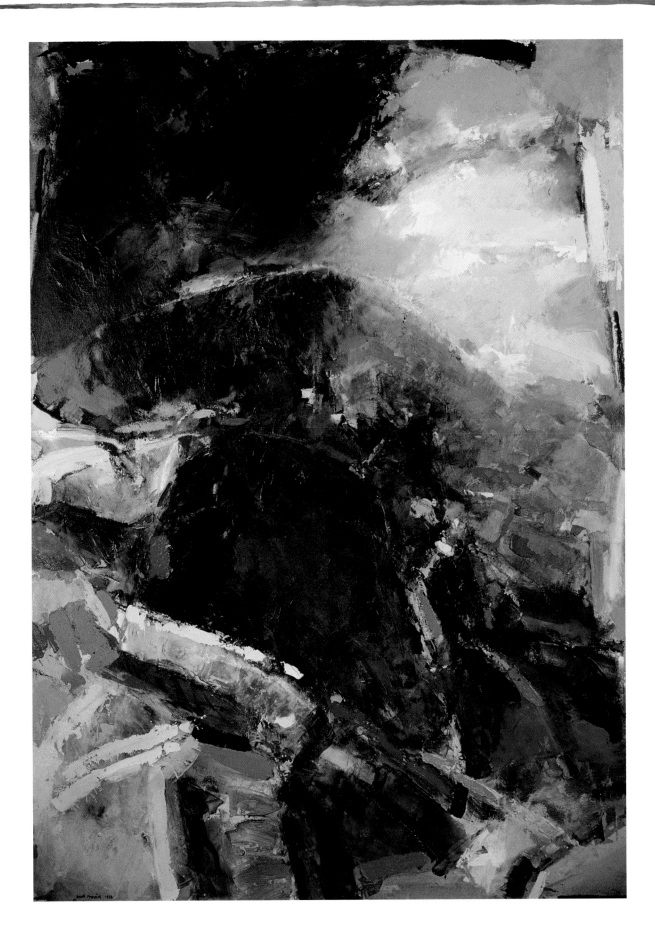

Elgar's Spectrum, *1988–93*
oil on canvas
1525 × 1500 mm (60 × 59 in)
David started this painting away from his subject, in Northampton, before putting it into storage for four years and working on it again after his move to the Malvern Hills. The composition is based on a view of the hills looking north, but the forms and space are invented, developed during the actual process of painting the work. The sequence of blue, yellow and red glazes, suggesting a stormy, atmospheric sky, contrasts with the built-up impasto forms of the middle and foreground elements, and is echoed throughout the painting. This is underpinned by the tonal construction of the composition, which creates a sense of the three-dimensional landscape forms.

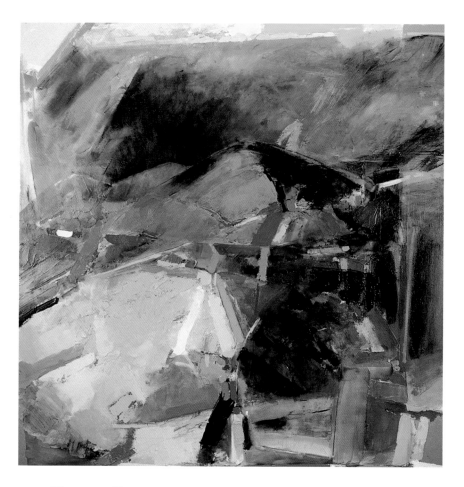

COLOUR CHORDING AND TONE

While he recommends starting with a limited palette, David enjoys using a 'full orchestral range' of colours. The wide choice of colours available is one of the greatest assets of the oil-painting medium for him, and he claims that 'to leave out certain colours would be like trying to play the piano with half the notes missing'.

His core palette comprises groups of colours (reds, blues, yellows, greens etc.), some of which are opaque and others transparent (for glazing). Some colours serve both purposes. His opaque colours include: Chrome, Lemon and Cadmium Yellow; Raw and Burnt Umber; Cadmium and Alizarin Red (also transparent); Sap and Hooker's Green (transparent) and Emerald Green; Cobalt, Ultramarine and Manganese Blue (all transparent); Coeruleum and Sky Blue; Ivory Black and Titanium White. Additional transparent colours include: Indian and UV Saturn Yellow; Raw Sienna and Asphaltum; Rose Dore, 'which mixes to make the most delicate pinks', UV Rocket Red and Madder; Payne's Grey and Zinc White, 'which makes the most wonderful glazes'.

He exploits what he calls 'chords of colours' to generate the sense of light and atmosphere in his paintings. Partly inspired by Turner's practice of painting patches of two or three primary-coloured washes onto paper as the basis of many of his watercolours to create a sense of illuminated space, David combines red, yellow and blue 'chords'. The

Air of Other Summers,
1992
oil on canvas
1475 × 1650 mm (58 × 65 in)
Compared with the invented
spaces of paintings like
Elgar's Spectrum, *this work*
is more specific in its reference
to a view of Worcester Beacon
and Wych Hill, looking
north. Note the colour
chording of red, yellow and
blue throughout the painting,
and the contrast between the
atmospheric glazes of
transparent paint in the sky
and the tactile impasto layers
of paint of the landscape forms.
Here, David has made
extensive use of beeswax, resins
and mediums to increase the
textural quality of his paint
and to vary the surface finishes
in the painting – this
contributes a physical energy
to the work.

graded sky of scumbled reds, yellows and blues in *Air of Other Summers,* for example, reconstitutes the atmosphere and light of the landscape without representing it literally. But it is the tonal structure that is the most important organizing element in David's paintings. As he says, 'there is no rule that says you cannot paint anything any colour you like'.

A Juggling Act

The development of a painting is a 'bit like a juggling act' for David. He will 'chuck everything in', and claims often not to know where he is going with a work. He deliberately sets himself challenges by adding a 'wrong note' of colour to a painting to force him to work around and with it, 'to get my brain going again' – a principle passed on to him as a student to which he still

adheres and which underlies his almost belligerent approach to his oil painting.

The *Nadir Roll* sequence shows clearly how, as a painting progresses, it becomes more complex in its tonal structure, range of marks, textures, transparent and opaque areas of colour, and surface finishes, until a feeling of stumbling through a physical space is effected for the spectator. The painting develops through a process of simplification by the use of glazing and varnishing. This is allowed to dry. The work is then recomplicated with brush and palette-knife marks, simplified again with glazes and so on until the painting is complete.

Influence and Inspiration

Ultimately, David emphasizes the necessity to take the technical issues of oil painting seriously; to work fat over lean, and to develop an instinct for painting through constant practice. As he says, you can take what you need from a professional artist or tutor, 'but you need to be passionate about what you are doing; this is nearly always acquired by example and often from other sources than painting.'

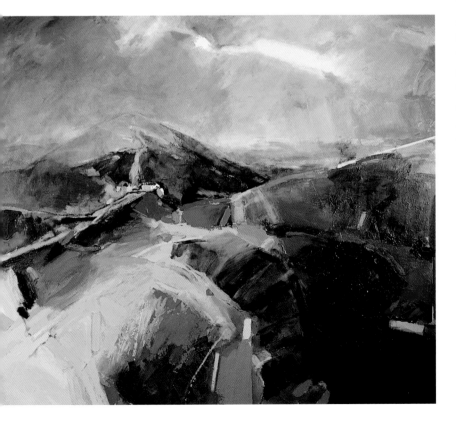

MASTERCLASS
with Philip Salvato

Philip Salvato delights in the rich, textural quality and depth of colour of oil paints, which he has used alongside watercolours, acrylics and gouache for the past 30 years. His richly coloured oil landscapes and portraits are painted with loose strokes of paint that evoke a sense of the poetry he sees in his subjects and seeks to express through his medium. His aim is to convey the elegance, depth and 'wonderful sense of beauty' he experiences as a painter, while giving the impression that his compositions have been effortlessly achieved.

Unlike the other *Masterclass* artists Philip prefers to spend time grinding his own oil colours in the traditional way because he feels that this gives him more control over, and a greater intimacy with, his materials. It allows him to make a short (buttery) paint or longer (more fluid) mixture by adding more stand oil to the medium in which he mixes his pigments, which offers him more possibilities for varying the texture of his paint. He can also make the paint as opaque or as transparent as he likes and control the drying times of his colours. Most importantly, he believes that knowledge of the chemistry of paints gives artists more choice when deciding how best to express what they want to say in their work.

▶ Self-portrait
oil on panel
510 × 405 mm (20 × 16 in)
The focus here is on the character of the sitter and the artist's concentrated gaze as he looks at himself in the mirror, seeking out the subtle nuances of tone that help to reveal the shape and structure of the head. The background and clothes are scumbled and drybrushed and remain undefined so that these areas do not detract our attention away from the main subject.

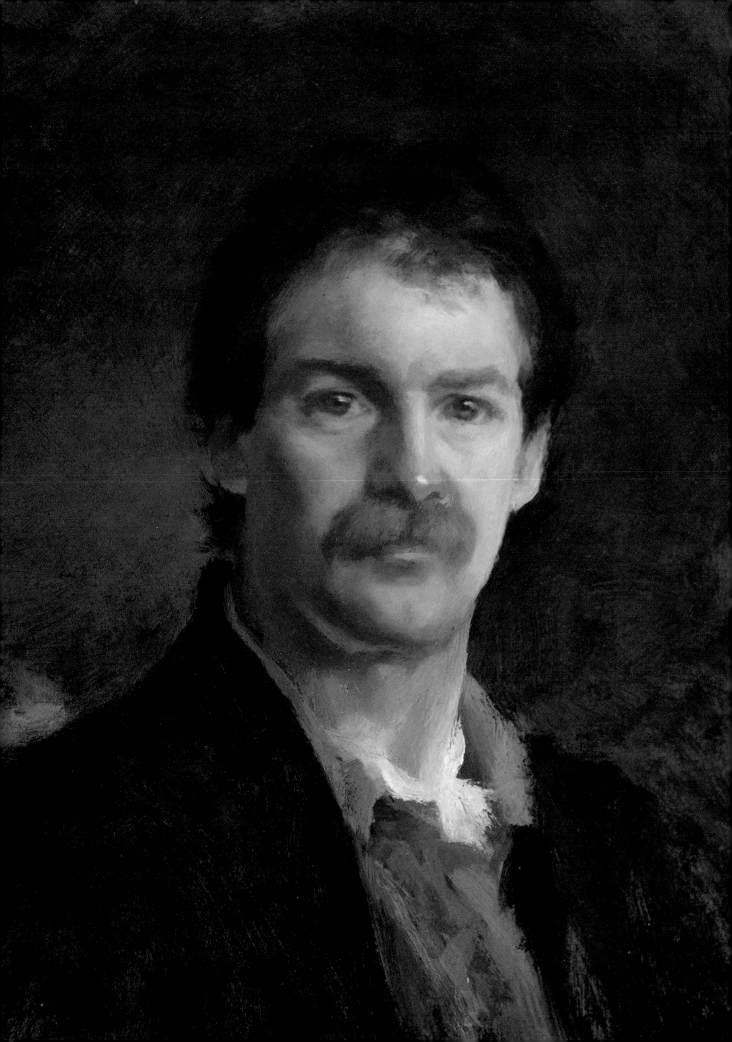

Le Pouldu

oil sketches on panels

150 × 225 mm (6 × 9 in) each
Each of the alla prima *studies*
on these pages was completed in
one to three hour sessions, using
a limited palette of Raw Umber,
Cool Grey and Blue Violet in
seven pre-mixed value ranges,
and Hansa Yellow, Alizarin
Crimson and Ultramarine Blue
with an occasional touch of
Cadmium Red Medium.
Philip's medium of stand oil
mixed equally with alkyd resin
helped the paint to dry quickly
and made the paintings easier to
transport as alkyd resin is not
sticky when dry.

In each study the colours
are exaggerated, and the blues
are wonderfully luminous. The
paint is sensuous and rich in
texture; it has been freely
brushed on in a gestural
manner, its robust application
evoking perfectly the rugged
texture of this area of Brittany.

MATERIALS

The surfaces on which Philip paints include oil- or acrylic-primed linen canvases, and birch plywood panels protected with a water-soluble sealer, or oil-primed with a particular appropriate colour.

His choice of brushes is crucial to his style of painting in which elements are suggested rather than carefully rendered. Inexpensive 12 mm (½ in), 25 mm (1 in) and 75 mm (3 in) housepainter's brushes are useful for the broad, early stages of a painting. Rounds help him to maintain a soft edge and by using the side of his housepainter's brushes, or filbert-shaped artists' brushes – which give him a wide edge – he can achieve a long narrow line when necessary. When selecting brushes for a painting, at whatever stage in its development, he always tries to use the largest possible, even when painting detail, because this helps to prevent the tendency to 'fiddle'.

MIXING AND PAINTING MEDIUMS

A firm believer in the importance of mastering the technical skills of oil painting, Philip grinds his dry pigments in various mediums in the traditional way using a muller, and mixes different resins, waxes and diluents with his paints, according to his subject, and the way in which he wants to express it. These additives include linseed oil, stand oil, turpentine, dammar resin, beeswax and alkyd resin. To make his paint quicker-drying for oil sketching outside he mixes his pigments with stand oil and alkyd resin in equal parts, which helps to accelerate the process, and puts his colours into tubes for transporting to his painting sites. This is the mixing and painting medium he used for his three *Le Pouldu* studies shown here.

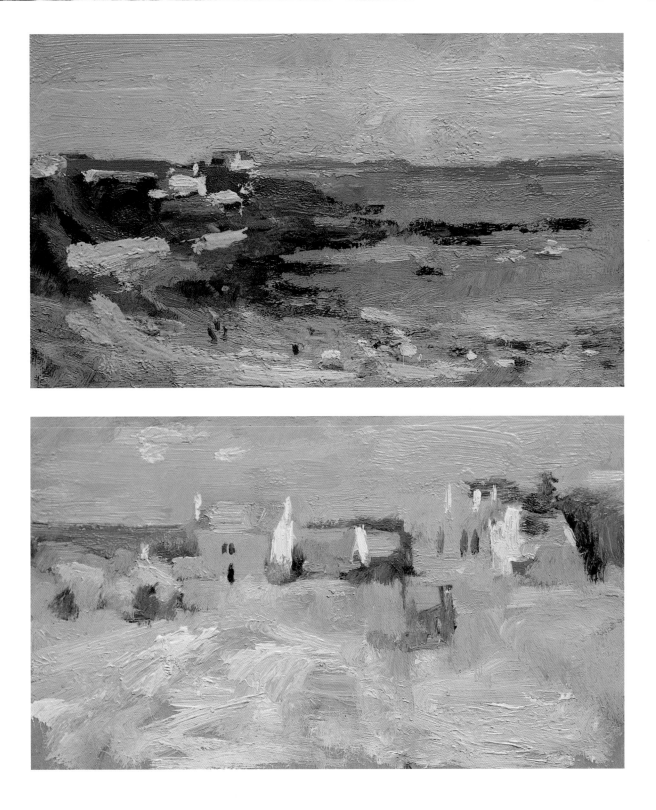

Philip's *Dufusky Isle* sketches and painting on canvas were made on the spot using pigments mixed with stand oil and alkyd resin for quick drying.

An additional aid to drying is his use of lead 'cooked' with his mediums. This is still available to a limited degree in the USA where Philip lives, and must be used with great care. He adds one-part lead carbonate to ten-parts linseed oil and cooks this mixture, stirring occasionally, at 250° Celsius on a stove outside, making sure not to inhale any harmful vapours. The oil darkens as the lead merges with it; and the darker it gets the quicker the colours to which it is added will

dry, giving him tremendous control over this aspect of his painting. He can add alkyd resin or wax, or both, to this medium, as required. When the mixture is the required colour, he strains it while warm and leaves it to cool. His *Self-Portrait* was painted using a medium of linseed oil and dammar resin cooked with lead, which was especially useful in the early stages when he needed the painting to be dry for the next day's work. Another advantage of this medium is that the painting will remain glossy and the darks dark, years after the painting has dried.

Philip adheres strictly to the rule of painting fat over lean; in making

Studies for Dufusky Isle
oil on panel
150 × 225 mm (6 × 9 in) each
Philip's exploration of his landscape subject in quick on-the-spot sketches such as these two studies gives him an opportunity to decide which viewpoint and composition will work best in the final painting. These are loose in painting style, consisting of dashes, slashes and quickly applied patches of paint, between which the natural colour of the panel is allowed to show through, giving unity to the painting.

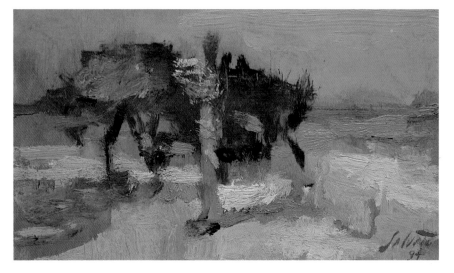

Dufusky Isle

oil on canvas

610 × 915 mm (24 × 36 in)

In the final composition Philip took up a position further away from the clump of trees, which acts as the main focal point in the painting. The converging paths lead the eye into the composition. Note how the pink of the underpainting, which adds warmth to the blue of the sky, is repeated throughout the painting, creating an overall harmony.

the mediums in which he mixes his powder pigments he usually starts by using colours mixed with a 'lean' medium of two-parts linseed oil and one-part dammar resin, moving to colours mixed with a 'fatter' medium made by adding stand oil as the painting progresses.

LIMITED PALETTES

For his landscape paintings Philip uses a basic combination of three primary colours: Hansa Yellow, Alizarin Crimson and Ultramarine Blue; or occasionally Hansa Yellow, Phthalo Rose and Phthalo Blue. To this combination he might

add a few brighter colours such as Cadmium Red Light which, added to Hansa Yellow, gives him a range of oranges, and Phthalo Yellow-Green, Phthalo Green and Phthalo Blue. In addition to these primary and brighter colours he will also use a range of dark to light tones of Raw Umber, and a range of dark-to-light blue-violets mixed from Ultramarine and Alizarin Crimson, plus several values of cool grey. As Philip points out, by limiting your palette in this way 'you don't become overwhelmed by so many colour variations and, especially in portrait painting, you have more control over the subtleties of the flesh tones because you have to

concentrate instead on tone and drawing rather than lots of colour.'

Philip's preferred portrait palette comprises Yellow Ochre, Raw Umber, Raw Sienna, Venetian Red and Ivory Black. He finds black 'a great neutralizer for brighter colours', although he warns that it must be used wisely. Sometimes he works with a wide range of values mixed from various combinations of Ivory Black and White with additions of Hansa Yellow and Cadmium Red.

By mixing the yellow and red he can create oranges, which he will temper with black if they become too rich. He uses violets and greens for flesh tints when the subject is in subdued lighting, or when he wants to create a sombre mood; if, alternatively, the person is in sunlight he might create these flesh tones from oranges and greens. As Philip says, there is no one correct way to create flesh tones, especially as these can contain so many colour variations. The most important factor is to look for the tonal values, and the individual character and gesture of the model.

APPROACH TO THE SUBJECT

Philip is attracted to a landscape or portrait subject by the variations of design and the major and subtle nuances of light in a scene – the light, middle and dark tones and the colours within these.

In his landscapes the achievement of a sense of the mood of a place is important for him. He loves being outside, watching the light change and looking for how this affects the underlying rhythms and combinations of shapes and patterns in a landscape. These describe the essential character of an area

and help to reveal the basic structure for a composition.

For his portraits he prefers to work in studio conditions under controlled lighting and where all his materials are easily accessible. Here, he works under a northern skylight, by side window lights or even under incandescent lighting, depending on the effect he wants to portray. The success of a portrait depends, as he says, on being able to capture the character of the sitter, for which drawing skills are essential, and it requires great concentration and clarity to see the connecting pattern of tones and rhythms of line in a face and figure.

For painting on location Philip Salvato uses a French-made compact travelling easel (seen here) in which he carries his materials. A large roll of kitchen paper is also important for wiping his brushes.

Philip Salvato's palette.

Philip Salvato's studio in Pittsburgh where he also holds exhibitions of his work.

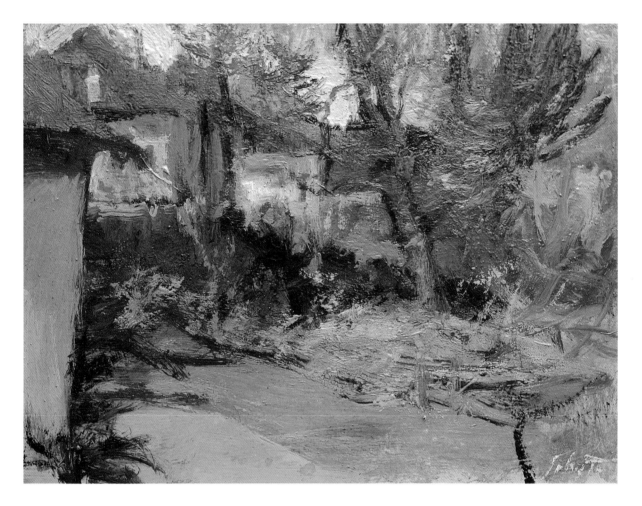

View from My Deck
oil on panel
225 × 305 mm (9 × 12 in)
This rapid study, completed in minutes, expresses an impression of the subject and has an energetic spontaneity about it. The colours are freely exaggerated, which helps to convey a poetic mood, and the loose strokes of richly textured paint suggest, rather than define, the basic composition.

PRELIMINARY STUDIES

To get to know his subject better Philip rehearses for the actual painting, often by making line drawings in pen and ink which 'help you to understand the essence of the subject and to find the rhythms within it'. For his portraits he also likes to make drawings in charcoal, which he regards as an ideal medium for studying the distribution of values in the subject: 'It goes on quickly and you can move it around, rub it in or lift it off your paper.'

Quick watercolour studies can help by providing colour notes and, if a subject is particularly complex, he may practise first by painting an initial oil study to solve some of the painting's difficulties. In such preliminary work he will explore how the light affects the shapes, tones and colours of a scene. Quickly painted oil studies like *View from My Deck* are often completed on top of old, discarded paintings, which speeds up the process by eliminating the need to start with an 'underpainting'; in effect this is already in place.

The most important function of preliminary studies such as the two oil sketches for *Dufusky Isle* is that they must contain enough information and energy to sustain Philip throughout the development of the final painting. This applies to all studies, whatever the subject.

DEVELOPING THE PAINTING

The start of an oil painting is when the magic begins for Philip. He begins by brushing on a thin under-painting in a colour that will inform or contribute a vitality to those applied on top. For the portrait of *Rick Everett*, for example, he used a warm Venetian Red and Ivory Black to enhance the subsequent cooler glazes he intended to apply.

At this early stage he begins to define the main tonal areas of his composition in loose, broad strokes, referring to the information con-tained in his preliminary studies, or

▲ 2

▲ 3

▲ 1

Rick Everett
oil on canvas
510 × 405 mm (20 × 16 in)
For this portrait Philip worked direct from his sitter on a stretched canvas with a prepared ground of thinned Venetian Red and Ivory Black paint. This provided him with a medium-tone key from which he could work up to the lights and down to the darks. At this stage he was feeling his way by drawing with the brush and nothing is too rigidly defined (1).

Concentrating on the head he then began to define and model its form and to pick out some of the highlights, scrubbing in dark values of Ivory Black mixed with Venetian Red and Ultramarine in the background, against which the head now emerges. Note how he has increased the size of the head and the depth of the neck compared with the earlier stage (2).

He continued to develop and model the structure of the head, contrasting delicate warm flesh tints with cool blue-grey shadows and paying attention to the way that these colours are balanced throughout the painting by his use of deeper values of them in the clothing and background (3).

In the final stage he worked these deeper values more into the clothing, strengthened the tones in the background and defined the detail on the face. The deep red drybrushed over the dark blue background to the right of the forehead enriches the warm skin tones and enhances the luminosity of the blues (4).

responding directly to his subject. For his on-the-spot landscapes, in particular, he enjoys working wet-into-wet and developing and refin-ing the shapes, tones and colours so that the elements come into focus slowly. Suggestion is the key to his approach here; there is no rigorous definition of form in his landscape paintings. As he says: 'It doesn't take many strokes to make a paint-ing. The trick is to find the right ones and sometimes it's better to sit

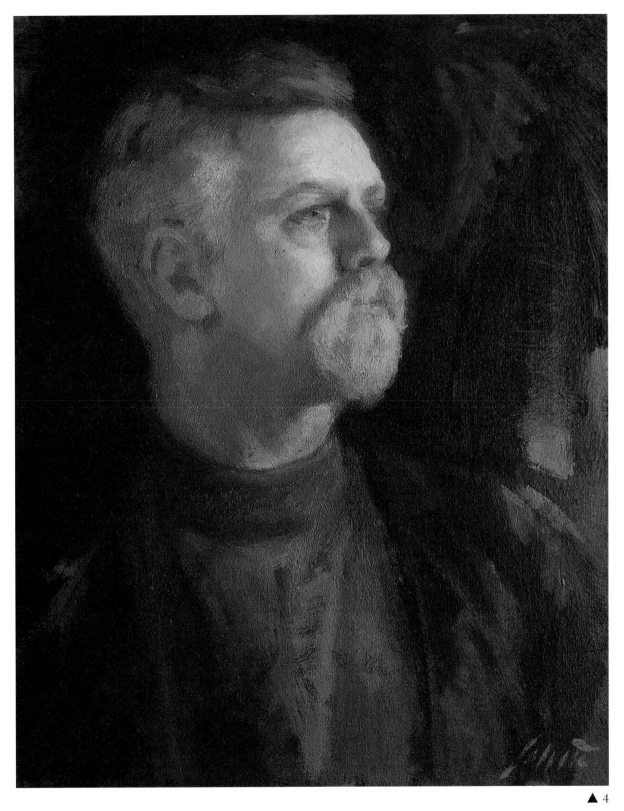

▲ 4

down and think a bit rather than keep painting.'

For more complex pictures, such as his portraits, Philip adopts a number of different practices to help regain the initial vigour which can fade during the development of a work over a long period of time.

Summit at Settlers Park

oil on canvas

405 × 610 mm (16 × 24 in)
Philip drove to the edge of this field and carried his materials to his painting site, to which he returned three or four times for a few hours on each occasion. The painting is divided into three simple horizontal bands, each defined from top to bottom by variations in value of Phthalo Blue, Phthalo Rose and Hansa Yellow. He built up the area of golden field on top of a crimson underpainting; you can see here his technique of scumbling fairly thick paint over already dried strokes, creating a surface texture that suggests the character and mood of his landscape subject.

These include scraping down a painting by laying it flat, pouring linseed oil over its surface, and then sanding it to remove excess paint until he reaches his desired surface, without going right back to the ground. Having wiped it clean, he continues with renewed energy, sometimes using a different range of colours to encourage him to take a new direction in the painting.

Less drastic is his method of scraping back to make corrections to facets of a composition – an area of colour in the wrong place, for example. Throughout all his work he uses different techniques, or approaches, according to the demands of his painting. Working paint wet-into-wet, wet-on-dry, scumbling, building up textural areas of sensuous impasto, applying transparent glazes one on top of another to modify underlying colours, dragging dry paint across a heavily textured area to create broken colour effects; all play their part in different paintings.

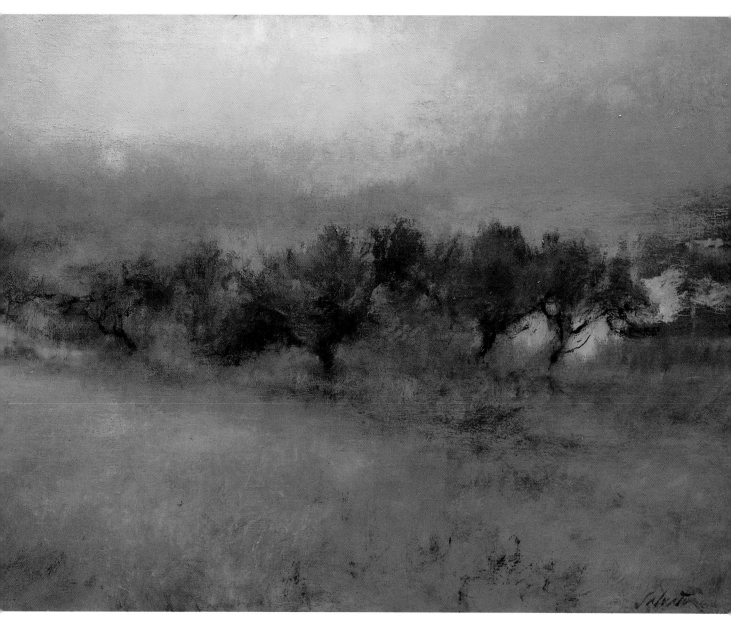

Sunset at Schulars
oil on canvas
710 × 1220 mm (28 × 48 in)
This high-key painting is dominated by Philip's use of pure Hansa Yellow and a touch of orange. Notice how the artist has simplified the landscape elements such as the trees, and the subtle modulation of the lights and darks so that the overwhelming effect of this painting is the intensity of the light which glows across the foreground and emanates beyond the confines of the edges of the canvas into our own space.

View from My Front
Porch
oil on panel
355 × 405 mm (14 × 16 in)
Intimate scenes like this,
selected from Philip's immediate
environment, make useful
subjects for practising his
commitment to paint every
day. Here you can see clearly
how he layers strokes of thick
paint, applied rapidly, to build
up subtle nuances of colour,
and how he suggests the
impression of leaves and foliage
by the tonal placement, shape
and direction of small strokes
of paint.

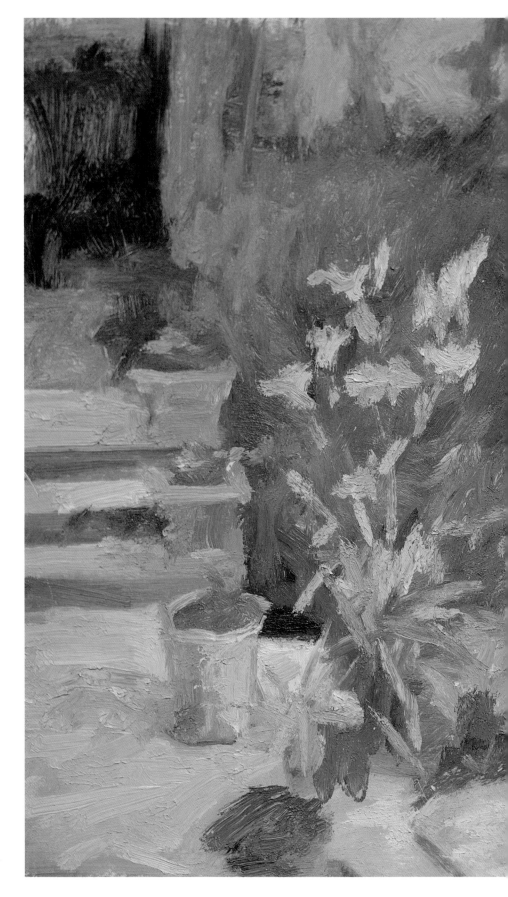

EXPERIMENT AND DEVELOP

Philip emphasizes the importance of painting regularly – daily if possible – in order to progress as a painter. He admits that this can be difficult, especially when you do not feel 'in the mood'. At such times he 'forces' himself to paint. *View from My Front Porch* is a 'forced' oil sketch, painted in about twenty minutes in the late afternoon after a busy day occupied by other things. It took a great deal of will and energy but the result of such an exercise, as this example shows, can be favourable and rewarding.

He also stresses the need to 'experiment with your work, try various combinations of surfaces, paints, mediums; keep developing technically. There are times when we must leave behind our comfortable painting methods and fly by the seat of our pants, combining various methods to arrive at the finish.' To be able to identify strengths and weaknesses, and ways to improve these is also important. As he says: 'Learn from the past. Take risks with your art.'

MASTERCLASS
with Meg Stevens

A much later convert to oil painting than the other *Oils Masterclass* artists, largely because she worked for many years as a freelance illustrator and wood engraver, Meg Stevens' example shows how the discovery of a new environment can have an exciting and positive effect on your career as an artist, and take you into new areas of creative exploration.

Meg started painting seriously when she moved to Wales in 1974 and discovered Waun-y-mynach, a small area of unimproved common land characterized by a wide variety of wild grasses and native wild flowering plants.

Foreground grasses now feature predominantly in Meg's work. To focus on this aspect, which often takes up most (and sometimes all) of the picture area, she sits low in the grass. In such cases the nearest grasses almost touch her board and seeds drop onto the wet paint (sometimes these get varnished in six months later!). Grasses and flowers in the foreground of her pictures are therefore painted in detail, though never as botanical specimens per se. They are always shown as part of a total environment – the place which produced them.

Her choice of oil as a medium was governed by the rich and subtle colour which she found at Waun-y-mynach. As she says, oils offered her the opportunity 'to match the depth and glow' of the colours in her subject. At about the same time she also started working on a larger scale. All her work now is rooted in her passionate concern to celebrate the beauty of our slowly vanishing natural environment, and the desire to point out, by painting it, the tragedy of such loss.

September Grass
(Waun-y-mynach)
oil on hardboard
502 × 502 mm
(19¼ × 19¼ in)
The brilliant sky and white clouds in this painting were completed in the first hour of the first sitting. Note how the mountain is just a shade darker blue than the lower range of clouds on the horizon. Working down from the mountain, Meg painted the rest of the composition in a neutral ochre colour, getting darker towards the bottom. The wedge of dark shadow in the bottom left and the underlying triangular shape on the right-hand side form the compositional structure on top of which Meg worked at subsequent sittings.

Winter Grass:
Running Tide
oil on hardboard
610 × 610 mm (24 × 24 in)
*The rhythmic movement of the
grasses blown and battered by
the weather inspired Meg to
paint this scene. Having first
established the sky, she plotted
the main patterns and shapes
of the clumps and waves of
grasses in dark ochre, before
working in the main shadows*

*and lightly laying in the
lighter grasses over these while
the paint was still tacky. Her
brush consequently picked up
some of the underpainting so
that the grasses darken
towards the bottom, as they do
in reality. Meg makes a virtue
of this effect here, although it
meant constantly recharging
her brush with fresh colour.*

ASPECTS OF SUBJECT MATTER

Meg also looks for stretches of road-
side verge, canal towpath or old
churchyard grass before it is cut. She
points out that only when we can see
it in quantity can we experience the
colour and movement, and the drama
of grass – its behaviour under wind
and rain; blown, broken, and laid
low in winter, as in *Winter Grass:
Running Tide*. Her subjects also
include wild flowers in their natural

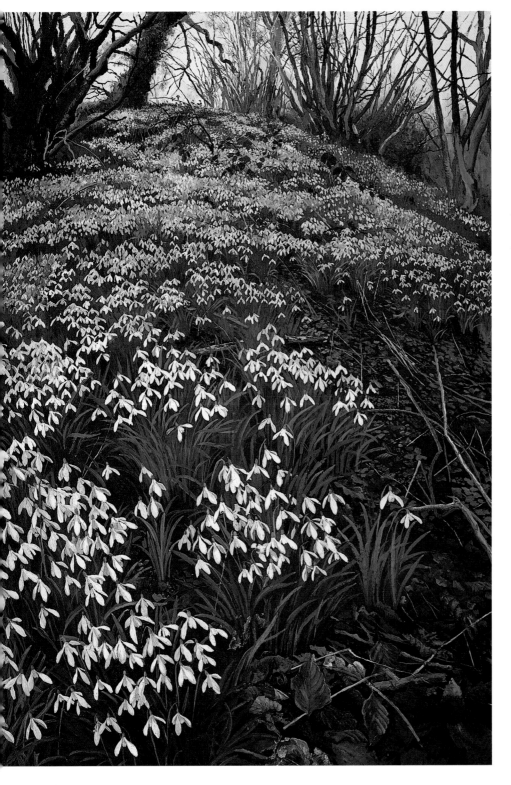

Snowdrops
oil on hardboard
610 × 420 mm (24 × 16½ in)
The trees here are merely suggested in black and grey silhouette; our focus is instead on the pattern of snowdrops in their natural habitat. These are indicated in the background by two curved strokes of the brush. To paint those in the foreground, however, Meg first painted the leaves, adding the flowers when the leaves were dry enough. Because of the cold and damp weather at some sittings she could only manage to finish four or five snowdrops at a time.

habitat, particularly when massed and as plentiful as in *Snowdrops*. She believes that wild flowers are meant to be seen thus and deplores their loss nationally.

Trees in their native woodlands, as in *Autumn Beeches*, are another favourite subject for Meg.

What she paints can sometimes be the result of an instant recognition of a picture waiting to be painted, or maybe a trick of light which transforms a view, but may not last long. As she says, being a landscape painter 'is to be a connoisseur of the fleeting and accidental'.

Often, it can be a matter of just having a go at something which she feels is probably going to be right, and sitting down to the task of 'painstakingly uncovering a pattern which I know must be there'. Great patience and perseverance are vital to the artist in the early stages, especially since nothing much may begin to emerge in terms of the composition until the second sitting.

Autumn Beeches
oil on hardboard
275 × 570 mm
(10¾ × 22½ in)
To make this complex
composition of trees against the
hazy sky convincing, Meg
plotted the position, thickness
and distance between the
trunks by making marks at the
bottom of her board. Having
established this overall pattern
of shapes she then worked in
the scaffolding of the branches
and added the main areas of
bronze-coloured paint to
indicate the masses of the
leaves, finally tidying up the
branches, adding the smaller
ones and, to finish, painting in
the leaves on the bank under
the oak tree.

MATERIALS FOR WORKING *IN SITU*

Meg works in all weathers and all seasons and this, too, can be physically exacting. Her usual sittings take three hours, sometimes five, but on occasion in very cold weather she cannot tolerate more than forty minutes ('I'm getting older all the time!,' she says).

She drives or rides her bike to reach her subjects, carrying her painting gear in a rucksack to her chosen painting spot. She uses a lightweight retractable-legged metal easel and a very small wooden-slatted camping stool, and two or three different sized hardboards: a 610 × 610 mm (24 × 24 in) board is a popular choice for her largest pictures – 'the square shape gives you a greater feeling of expansiveness'. Her other preferences are a 610 × 380 mm (24 × 15 in) board used either horizontally or vertically, and a smaller 305 × 380 mm (12 × 15 in) size which she uses when the weather is unpredictable and she needs to get the subject down more quickly. These are primed on the smooth side with two coats of an artists' quality oil primer, mixed with a little turpentine. A smooth white surface is important for her in the middle stages of her work when she scratches in some of the finer grasses with a scraperboard nib.

Meg's brushes comprise a 12 mm (½ in) square-edged soft brush for applying the ground colour, medium-sized soft-haired watercolour brushes (Nos 2 or 3, 5 or 6), and a couple of size 0 sables 'for the fiddly bits'. She trims these as the hairs become bent until she is left with just a few remaining straight hairs which 'for a short time is the best tool of all for giving me a beautiful hair line'. She might occasionally use a hog for quick, initial applications of colour, although on a smooth board this can give a streaky effect. These, as well as her five or six tubes of colour, and turpentine in a plastic pill jar, are carried in a plastic sandwich box, the lid of which she uses as her palette.

COLOURS OF THE SEASONS

The colours which Meg uses vary according to the season, though she rarely uses more than five or six for any particular work. These include Titanium White, mixed with Ultramarine for skies; Chrome Lemon and Chrome Yellow Deep mixed with Sap Green, or Ultramarine for greens; Yellow Ochre and Indian Red, maybe a touch of Magenta in autumn; and Black. She has experimented with Viridian mixed with Chrome Lemon for the blue green of spring grass, as in *Bird Cherry and Buttercups*, but finds that this, like Magenta, alters in artificial light, turning too fierce.

For Meg there is no other colour than Magenta for foxgloves and a touch of it with blue, for bluebells, but there are other choices available to replace Viridian. For her it is a matter of finding what suits best, looking for the most permanent and refusing to use colours that may damage the environment.

Bird Cherry and Buttercups
oil on hardboard
610 × 475 mm (24 × 18¼ in)
Meg worked faster than usual on this painting to establish the pattern of shadows before the light changed. She worked into the dark green and sun splashes at the first sitting and did not alter this much except to tidy up the composition. She did so at the second sitting by putting in some of the grass stalks along the edges where the light falls between the trees and their shadows.

Meg Stevens working in situ.

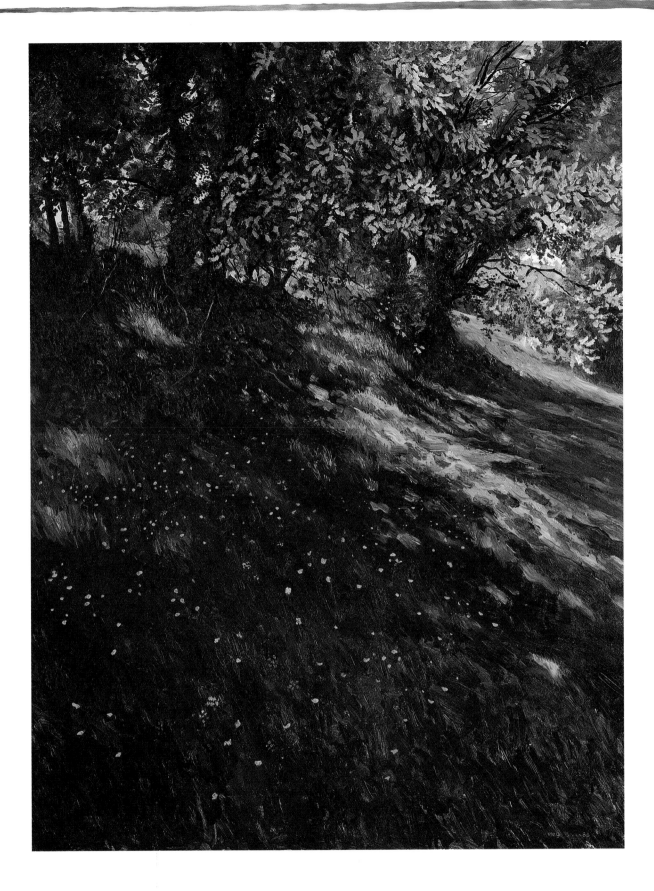

Winter Sunset
(Waun-y-mynach)
oil on hardboard
610 × 610 mm (24 × 24 in)
*The silhouetted black trees
against the late winter
afternoon sun inspired this
painting. Meg established the
sky first, then roughed in the
trees and covered the rest of the
painting with a neutral brown
tint. This eradicated the
whiteness of the primed board
and stopped it from competing
with the brilliance of the sun.
The foreground docks were
painted last. Note how these
dark shapes balance the trees
on the horizon and lead the eye
up to the white sun.*

Black is an important colour in Meg's winter palette, although she comments that 'if you can get your darks with other colours, there's a case, especially for inexperienced painters, for arguing that that's what you should do. Often, close examination of dark areas will produce the astonishing conclusion that they're purple or blue, or both.'

On the other hand, for winter trees or bushes against a winter sunset, as in *Winter Sunset (Waun-y-mynach)*, 'you can't achieve this effect with anything other than lashings of luscious black'. She also uses touches of black in the darker parts of the trees and shadow areas

in sunny summer views 'to set them back'. This helps to enhance the brilliance of the sky and other colours in the composition.

DESIGNING THE PICTURE

Whatever the subject, weather or light conditions, Meg stresses the importance of being 'ruthlessly honest' about what you are looking at, which means 'analysing the shape of things themselves and the shape of the spaces around them, as well as the patterns within them'. This strong design element in her work is underpinned by skilful draughting,

Melting Snow
oil on hardboard
610 × 610 mm (24 × 24 in)
To combat the cold Meg
wrapped herself in an old duvet
to capture this subject, which
necessitated working quickly to
establish the overall pattern of
shapes before the snow melted
completely. She finished the
painting in one sitting, hence
the impressionistic handling of
the bottom-left foreground.

which she attributes to years of practising life drawing as a student, which, as she says, 'helps you to look at things properly'.

Her visual analysis of her subject into its prominent patterns and overall tonal design is one of the keys to the success of her paintings. It helps her to deal with what might sometimes appear to be overwhelming complexities of detail. As she explains, you should try to see your subject at its most basic, whittled down to sky and 'not sky'. For Meg it is vital to get these two elements in correct relationship, although she points out that to do this you may have to cheat because you have nothing in your box to match such things as the brilliance of a winter sun.

ESTABLISHING THE SKY

Meg works quickly in the early stages of a painting to establish the sky, which is always done first – 'lids fly and brushes scatter when I'm doing skies!' To give the illusion of its brilliance she may sometimes make the horizon below darker than she sees it. Once this relationship is established convincingly, however, she will key the rest of the picture into that.

Meg Stevens sometimes rides an old push-bike to her painting spot, carrying her materials in a rucksack.

FINISHING THE PAINTING

As most of Meg's paintings contain a lot of detail, especially in the foregrounds, they take at least three sittings; some, especially flowers, take much longer. *Snowdrops*, for example, took three weeks ('I kept being rained off'). Even so, as Meg says, 'although my paintings are so detailed, you can't paint everything in – life isn't long enough and it wouldn't look right anyway!' The answer, she emphasizes, is to be fierce with yourself and to be prepared to edit things out. Although many of the foreground marigolds in *Corn Marigolds* are painstakingly painted, for example, the more distant ones are merely suggested by cursory dabs of paint; overall this creates a dazzling effect.

Instinct tells Meg when a painting is finished. As she points out, the crucial thing is to know when to leave the painting alone and when it looks 'right'. This means 'knowing that if you go any further you won't really be adding to it'. A final layer of varnish helps to 'bring back dark colours that go matt when they've dried out' and makes the painting 'come alive and glow again'.

Corn Marigolds
oil on hardboard
480 × 355 mm (19 × 14 in)
Divided almost exactly into two vertical halves, this composition contradicts the usual rules of composition. Nevertheless, it helps to emphasize the brilliant colour and variety of this herbaceous border at the edge of a corn field, and in any case the composition is 'anchored' by the solid horizontal line of bushes at the top of the painting. Note, too, the subtle elongated triangles underpinning the composition that lead the eye into the background and the distinct vanishing point placed in the middle background.

MASTERCLASS
with Kyffin Williams

Kyffin Williams' name is as synonymous with the technique of painting in oils with a painting knife as it is with the Welshness of his subject matter. He takes his inspiration from his beloved north Wales, where his work embraces rugged landscapes, vigorous seascapes and, as you can see in this masterclass, portraits of local people that are highly charged with a passion and tension that derives partly from the enormous energy with which he creates his paintings, and partly from the direct physicality of his painting technique.

Kyffin began using a painting knife at the beginning of his career, in around 1943, because it allowed him to indulge to a greater degree in the rich and sensuous tactility of thick oil paint. Its use has enabled him to create paintings that become objects with an immense solidity and almost three-dimensional presence.

Painting thickly with a painting knife in oils in the manner that Kyffin adopts demands a direct and spontaneous approach because he only has one attempt at the work. All Kyffin's paintings – his landscapes done on the spot or from drawings in the studio, and his portraits – are completed in a day. The frustration inherent in this is that from the point of view of a likeness a portrait can sometimes be a 'bit hit and miss'. For this reason, especially with commissioned portraits, Kyffin emphasizes the importance of concentrating as much on the pictorial qualities of the portrait as on attempting to achieve a likeness – an aspect that inexperienced painters often neglect. As for most figurative painters, and true of the other *Oils Masterclass* artists, the constant problem for Kyffin is this 'dangerous' tightrope walk between abstraction and realism.

Dr Alun Oldfield Davies, CBE, 1982 (detail)
oil on canvas
full size of painting
1830 × 915 mm (72 × 36 in)
COLLECTION BBC WALES
For this work, commissioned by BBC Wales, Dr Davies stood in the corner of Kyffin's studio, while the artist worked on his life-size canvas both on the easel and then on the floor. To make him appear tall – he is over 6 ft in height – Kyffin allowed his subject's trousers to touch the bottom of the canvas, cutting off his feet and making it unclear how long his legs are. Note the concentration on the myriad of lines creasing Dr Davies' face and the heightened contrast of his dark suit against the pale grey background, so that he appears powerful and serious.

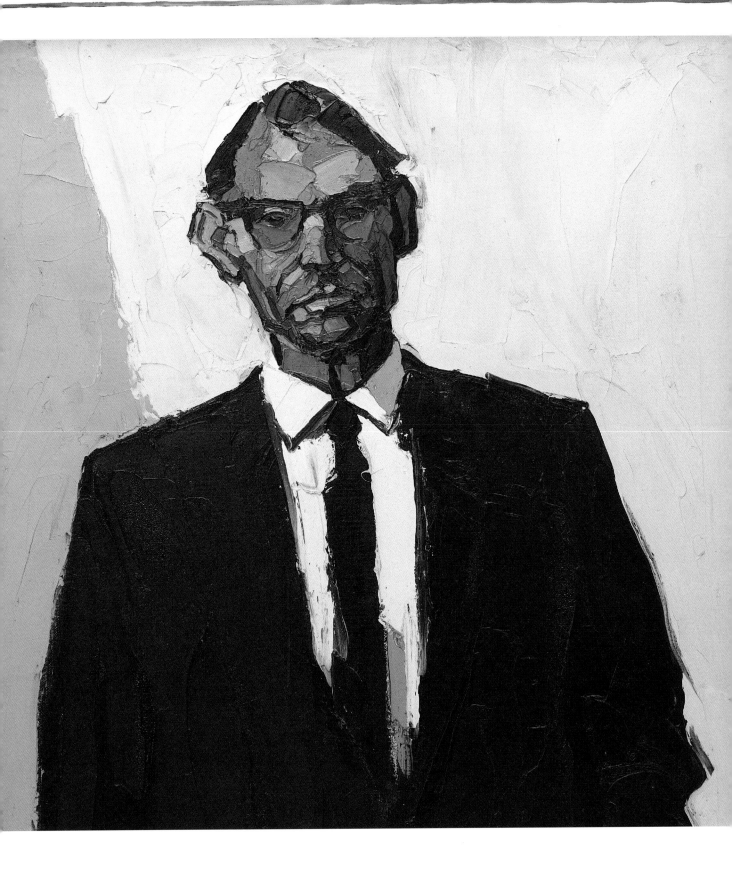

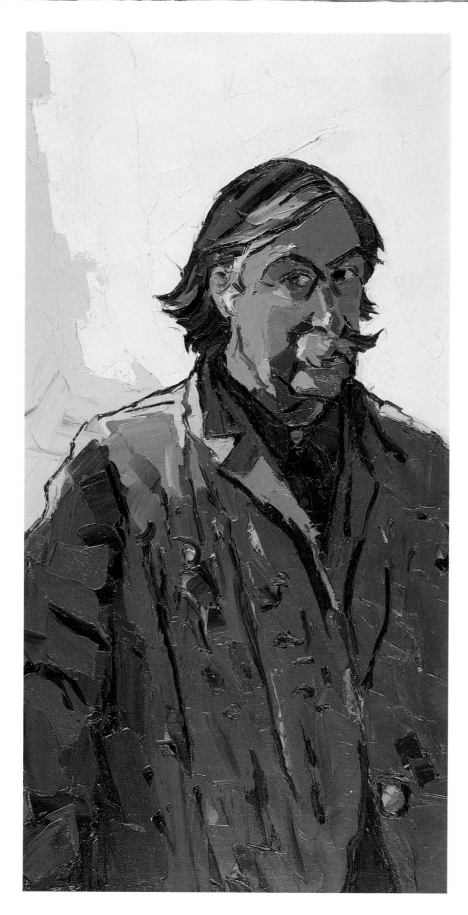

Self-Portrait, *1978*
oil on canvas
1120 × 560 mm (44 × 22 in)
Many artists paint self-portraits because they are convenient models. This is an important factor for an artist like Kyffin, who sometimes finds it difficult to ask a person to sit for him. He has painted many self-portraits, but this is one of only a few that he has kept, partly because he finds it more difficult to paint a successful picture from his own mirror-image than from another sitter.

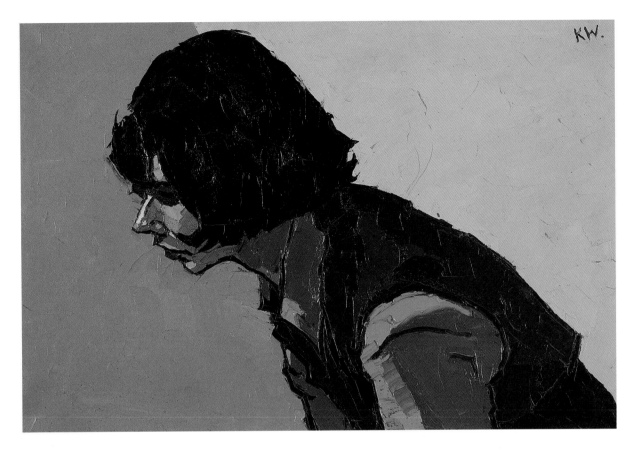

PAINTING WITH A PAINTING KNIFE

One problem that Kyffin became keenly aware of early on during the development of his painting-knife technique, is that certain colours dry unevenly if they are applied thickly over a loosely applied, only partially dry, underpainting. Also, in the case of the umbers especially, a skin will form under which the paint will dry inconsistently, causing the surface to 'pucker'. As Kyffin enjoys working with solid, flat passages of paint that dry with smooth surfaces, his practice is always to apply his paints straight onto ready-stretched, white acrylic-primed linen canvases, guided by a preliminary drawing in of the composition, for which he uses a sable brush and thinned, invariably black, paint. He never starts any of his work in oils with an initial underpainting.

The danger in working with a painting knife, though, as Kyffin warns, is that you can easily become absorbed by the glory of rich paint for its own sake and lose the sense of what an area or passage of paint is intended to say. The answer, always, is to be ruthless with yourself and ask yourself if it does the job it is required to do. If not, 'scrape it off'.

He uses two trowel-shaped painting knives for the majority of his work, and a smaller one for more subtle manipulations of colour such as the highlight on the nose in *Yolanta in Profile*. All of the knives have cranked shafts, essential for keeping his fingers away from the wet canvas surface. The vigour with which he attacks his canvases, in a way that sometimes borders on the irreverent, means that the knives occasionally break, so replacement ones are often necessary. Another

Yolanta in Profile, *1967*
oil on canvas
610 × 915 mm (24 × 36 in)
Kyffin asked if he could paint Yolanta because he was fascinated by her mop of dark hair, sensitive face and long, attractive nose. To enable him to concentrate on these features he painted her in profile, leaning forwards across the canvas. Her features are etched dramatically against the simple background which is split into a mid and light tone as a counterpoint to the tonal construction of her face, and darker hair and back. She seems almost sculptural against the plain background, the solidity of her form emphasized by the tactile nature of the application of the paint. Note the impasted highlight which draws attention to her nose.

119

Lady Amelia Paget, *1968*
oil on canvas
700 × 500 mm (*27½ × 19¾ in*)
COLLECTION THE MARCHIONESS OF
ANGLESEY, DBE

The large mass of the dark green chair in which four-year-old Lady Amelia Paget is seated, emphasizes her small size in this painting, which was completed in only about an hour and a half. The two blues work well with the green of the chair, while the child's red hairband gives the painting an exciting splash of colour.

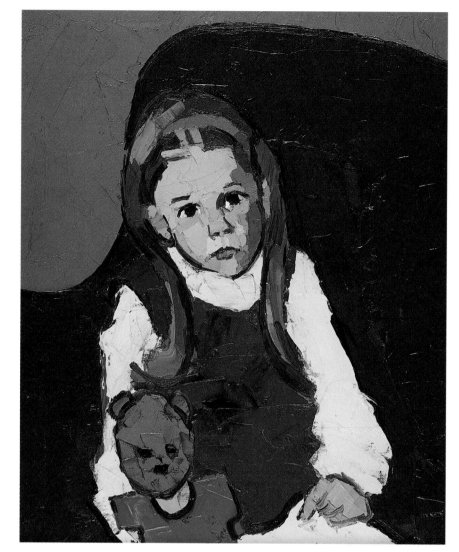

COLOUR AND TONE

important studio item is an old telephone directory, the pages of which he uses to wipe his knives clean between applications of paint.

Apart from the turpentine used to thin his paint for the initial drawing in, Kyffin prefers not to use any medium with his colours. Indeed, his painting technique demands the use of colours that have a certain 'weight'. Titanium White is not suitable, for example, while Flake White is ideal because it has the required amount of 'body'. In addi-

tion transparent Golden Ochre is too light; Cobalt Green on the other hand has the 'solidity' that he looks for and is 'lovely to use'. This is not a standard colour in his palette, however, as he usually prefers to mix his own greens.

In fact, Kyffin's palette is rigorously restricted. It comprises Flake White, Ivory Black, Lemon Yellow, Aureolin Yellow, Yellow Ochre, Raw or Burnt Umber and Cobalt Blue. He adds Cadmium Red, Cobalt Green and sometimes Cadmium Orange as necessary. Problem colours for him include Prussian Blue and Alizarin Crimson, which he warns are 'so powerful

Hugh Thomas, *1950*
oil on canvas
610 × 510 mm (24 × 20 in)
COLLECTION UNIVERSITY OF WALES,
BANGOR

Following the death of his wife, this farmer's doctor asked Kyffin to paint him to distract him from the pain of his loss. A typical north Welsh Celt, his drooping moustache and sad eyes accentuate the melancholy in his face. Kyffin painted him in the rickyard seated on a stool against a blue stable door. Note how the sunlight picks out his neck and cheekbones, the back of his cap and the edge of his moustache.

that they can destroy your palette'. The important factor, as he points out, is to 'find what you can and can't do'. In his case he learned very early on that as he is 'no colourist', he should limit his palette. Instead it is his skilful handling of tone that is the key to the powerful effect of his images. Note, for example, the tonal construction of the face of *Hugh Thomas*, and the dramatic contrast of his white shirt against the dark grey background of the painting.

Indeed for Kyffin, as for most painters, the sign of a good artist and the quality he most admires in other painters' work, lies in the command of tone. When he paints a portrait of a child, as in the case of *Lady Amelia Paget*, for example, his strategy is to block in the whole composition in a fairly abstract way, focusing on getting the balance of tones right, before briefly and quickly adding the features towards the end of the painting with a sable brush, 'to tie it all up'. As he explains: 'With children moving all the time you've got to have some way of doing them and this is the best way.'

His colours and tones are invariably exaggerated from his subject. As in a drawing such as the study of *Thomas Jones*, which is expressed

in dramatic black lines and washes, he tends to expand his tones in his paintings to make tonal contrasts stronger than they are in reality. He loves the excitement of dark against light and uses a lot of unrelieved black. Notice, too, particularly in the portrait of *Yolanta in Profile*, his use of black line to differentiate between forms. He warns, however, that to do this successfully it is important to use a broken, 'lost and found' line or it will be 'too harsh'.

▲ Thomas Jones,
Fronddu, *1976*
ink and wash drawing
510 × 710 mm (20 × 28 in)
COLLECTION DR A. F. S. MITCHELL
Kyffin first drew this old sailor on the roadside, inspired by his deep-set eyes, large nose and gentle smile beneath his heavy moustache. This ink and wash study emphasizes the artist's passion for playing dark against light and strong tonal contrast; he went on to develop this in the subsequent painting.

▶ Thomas Jones,
Fronddu, *1976*
oil on canvas
915 × 915 mm (36 × 36 in)
COLLECTION MR AND MRS PATRICK SMITH

There is a greater element of abstraction in this portrait painted from the earlier drawing than in Kyffin's paintings completed from life. The emphasis here is on the stark contrast between the light lemon background and Thomas Jones' dark warm grey face. The portrait relies heavily on lost and found black lines to delineate the old sailor's facial features and his clothes. The change in scale from the earlier horizontal sketch to this square format, gives this portrait a monumental feel.

A PASSION FOR PORTRAITS

Although Kyffin paints mostly landscapes and seascapes, he particularly loves the challenge of portrait painting. As he explains: 'You can't take liberties with portraits as much as you can with a landscape where you can cut down woods and alter the shapes of mountains to make the picture.' For him the achievement of a likeness and a reasonable painting is far more satisfactory.

He is obsessed by the people of Wales, whom he paints for his own pleasure – he rarely accepts commissions these days because of the worry of satisfying his patron. Local farmers, children, people with accentuated features and faces full of character are his preferred subjects, while conventional beauty interests him little as perfectly placed features turns portrait painting into 'a bit of a bore' for him.

His practice is almost always to paint his portraits direct from the sitter. Although he has occasionally painted them from drawings, as in the case of *Thomas Jones*, he warns that by doing so, 'you tend to be slightly more clinical'. As he says: 'Paintings from drawings are less exciting.' He never uses photographs, although he has no real objection to them as long as they are not simply copied. Instead, he believes firmly in the advantages of painting direct from the subject, when unexpected and exciting things can happen on the canvas and lift the painting as you struggle to interpret what is in front of you.

During this battle the character of Kyffin's sitter may change dozens of times, as a simple flash of the knife or flick of the brush can alter a look of confidence into one of apprehension, or arrogance into compassion. The important job of the portrait painter, for Kyffin, is to seize on a sudden revelation and hang on to it. Of course, in practice this is an 'agonizing' process because with every adjustment you can so easily lose it. Additionally, it can be difficult to return to because scraping back too much disturbs the surface of the priming and causes the paint to sink.

Another technical difficulty is the problem of suggesting the delicacy of younger skin with thick, textured paint applied with a painting knife. Kyffin readily admits that for a long time he found it easier to paint elderly people; indeed, he says it took him about twenty years to achieve a satisfactory portrait of a young woman. Yet, handled well, Kyffin emphasizes that the technique does offer an important advantage, especially when painting the light falling on a cheek, for example, which must be 'fresh' in execution. This is especially noticeable in the portrait of *Richard Williams* shown here.

▶ Richard Williams, *1955*
oil on canvas
500 × 400 mm
(19¼ × 15¼ in)
PRIVATE COLLECTION
A danger when painting in oils with a painting knife is that the paint surface can potentially become clogged and dull. One method for avoiding this is demonstrated clearly in this painting of the artist's elderly gardener, in which Kyffin has applied colours which he only part-mixed on his palette first. When colour is applied in this way, streaks of the component colours mix with each other on the canvas surface, creating a shimmering effect of light – as you can see on Richard Williams' cheek, for example.

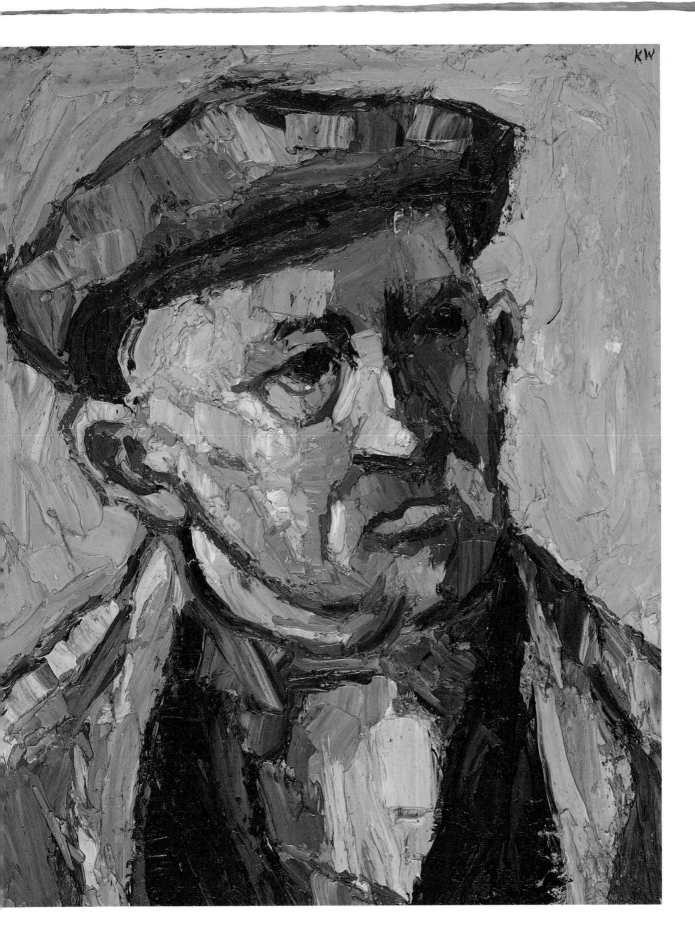

Kyffin Williams in his studio, Anglesey, 1983 (photograph: Nicholas Sinclair).

COMPOSITIONAL CONSIDERATIONS

Although Kyffin's portraits are imbued with a great sense of the character of the sitter, surprisingly this is not his overriding consideration in front of his subject, except when making decisions about the placing of the figure on the canvas. He comments that it is simply 'common sense' not to fill the whole canvas with a child's figure, and to make the body of a large and confident man fill the canvas and almost touch its edges.

The last thing he really thinks about when he starts a portrait is the background, however. Although its colour is put in to relate to the rest of the colours from the start, and the painting develops as a whole rather than in isolated parts, he begins a portrait from the area between the eyes; then follows this by developing outwards from the eyes, the nose, the mouth, the whole face and so on. Another important technical reason for working from the middle areas outwards is that with the painting-knife technique you have to be careful not to get too much thick paint around the edges of the canvas because this can create problems when framing.

In effect, for Kyffin the development of a painting is a process of considering and adjusting all the various stresses throughout the work until the surface is 'taut and tight' within the confines of the canvas, with no area left unrealized. Only when the whole thing has a sense of totality about it, is it finished for him.

AN OBSESSIVE PAINTER

Perhaps one of the most encouraging aspects of Kyffin Williams' approach for other painters is his absolute belief in the importance of an artist's obsession for painting, rather than his talent, which he modestly claims not to have. As he explains: 'One of the disasters of contemporary art is that many artists don't love what they paint; they paint in order to make a dramatic effect. I believe that your influence should come from the object you're painting and the fact that you're barmy about what and how you're painting.'

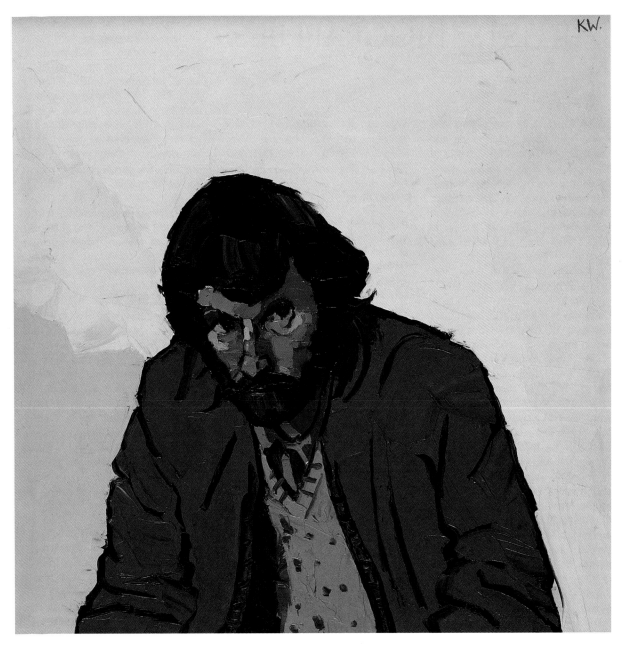

KW.

Keith Andrew, *1984*
oil on canvas
760 × 760 mm (30 × 30 in)
COLLECTION NATIONAL LIBRARY OF
WALES

*Keith Andrew is
predominantly a watercolour
painter whose understanding of
Anglesey impresses Kyffin. His
sensitivity and diffidence are
expressed by his position on
the canvas and his sideways
glance and, as in all Kyffin's*
*portraits, the plain and simple
background acts as a tonal
counterpoint to the main
subject. This is partly for
expedience; it would be
impossible to develop a detailed
and subtle background when
painting a portrait in one
session, as Kyffin's oil
technique demands.*